MASTER CLASS PHOTOGRAPHY SERIES

IN-CAMERA
SPECIAL EFFECTS

Mike Stensvold is a self-taught photographer and a graduate of San Fernando Valley College. He is the author of four photography books and many magazine articles, and was Technical Editor of *Petersen's Photograhic* magazine.

The Master Class Photography Series
Better Black-and-White Darkroom Techniques
Creative Still Life Photography
Improving Your Colour Photography
Techniques of Portrait Photography
In-Camera Special Effects
Colour Processing and Printing

MASTER CLASS PHOTOGRAPHY SERIES

IN-CAMERA
SPECIAL EFFECTS

Mike Stensvold

Macdonald

A *Macdonald* BOOK

This edition published in Great Britain in 1985
by Macdonald & Co (Publishers) Ltd
London & Sydney

A member of BPCC plc

First published in Great Britain in 1984 by
Blandford Press, Link House, West Street, Poole, Dorset BH15 1LL

British Library Cataloguing in Publication Data

Stensvold, Mike
 In-camera special effects.—(Master class
photography)
 1. Photography—Special effects
 I. Title II. Series
 778.8 TR148

 ISBN 0-356-10488-5

A Quarto Book

Produced and prepared by Quarto Marketing Ltd.
15 West 26th Street, New York, N.Y. 10010

Project Editor: Sheila Rosenzweig
Art Director: Richard Boddy
Design Assistant: Mary Moriarty

Typeset by Associated Typographers
Separations by Hong Kong Graphic Arts Service Centre
Printed in Hong Kong by Lee Fung-Asco Printers Ltd.

Macdonald & Co (Publishers) Ltd
Maxwell House
74 Worship Street
London EC2A 2EN

Contents

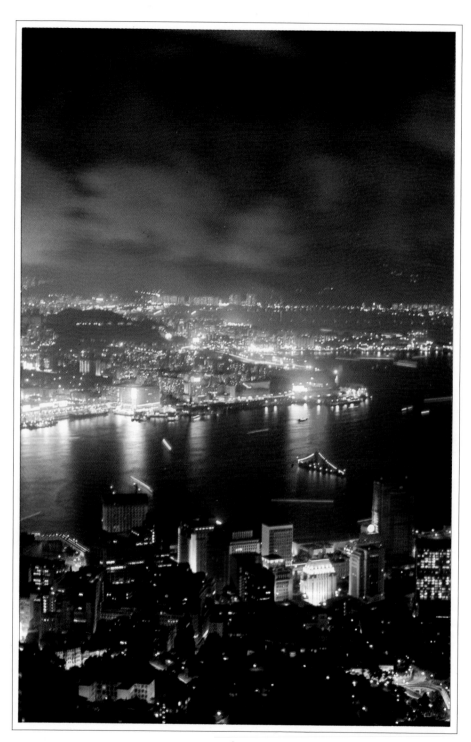

Introduction

SPECIAL-EFFECTS PHOTOGRAPHS ARE SPEcial. They're out of the ordinary. In some special-effect photos, the effect is dramatic, a real eye-grabber that makes you wonder how the photographer did it. In others, the effect is subtle, and you might even have to study the picture for a while before you see that the photographer did something special to create the image. Either way, this book will show you how to make these special images yourself.

Like all photographic techniques, special effects are simply tools at your photographic disposal. To learn them, you must practice them, one at a time, until you've mastered them. Each time you master an effect, you can add it to your bag of tricks, for use when needed.

The purpose of any special effect is to produce a better photograph than you'd get without the effect. Not every image will be improved by using a special effect. As the work of Ansel Adams and many others proves, a talented photographer can produce wonderful images without effects, using only camera, film, and mind. If you use a special effect just for its own sake, as a gimmick, the resulting image won't be as effective as a straight rendition of the subject.

Once you've mastered special effects, leave them in your bag until your mind tells you, "This image will be dynamite if I use this effect." But while you're learning the techniques, go ahead and use them on anything you like. Evaluating the results, discovering when each effect is effective and when it isn't, is an important part of the learning process.

It's very easy to get carried away with each effect when you first "discover" it. That's O.K. Such enthusiasm inspires you to practice the effect, and practice is important if you are to master it. So discover each effect, get carried away, have fun, practice, and learn. Once you've mastered the effect, add it to your photographic repertoire, then use it only when it will enhance your image.

Each special effect should be used for a reason, and that reason is always the same: because the effect will produce a more effective image than you'd get without the effect. If you keep that in mind, you'll be in no danger of using special effects just as gimmicks to dress up otherwise dull images. But the ultimate decision as to whether an effect is appropriate or not is yours — if you like your image, the effect is right. If you don't like a result, you've learned something, and will do better next time.

One wonderful benefit of special effects is they make you think. You have to "see" your image in your mind before you can use an effect to produce it. You can't snapshoot special-effects images. Since special effects force you to visualize your images before committing them to film, the more you work seriously with them, the more used to visualizing you'll become. This will help all your photography, because the main difference between snapshots and photographs is visualization. The snapshooter just points and shoots; the photographer thinks first about how best to record his image.

Some special effects can be done with just camera, lens, and knowledge of the effect. Others require special equipment, ranging from very inexpensive to quite costly. But whatever your budget, you'll find a lot of effective techniques well within it here. So let's get started.

1

Focus Effects

YOU DON'T NEED A LOT OF FANCY EQUIP-ment to produce many fascinating and unusual special effects. With just your camera and lens, you can use selective focus, long exposures, short exposures, multiple exposures, lens flare, reflections, and shadows to create images that are quite extraordinary. The first four chapters of the book will show you what you can do with just your basic camera and lens.

One of the simplest techniques is selective focus: Focus sharply on your subject, and open the lens aperture all the way to throw everything else in the picture out of focus. Generally, you'll want to open the lens to its widest aperture to produce minimum depth of field, but sometimes you'll want to close the lens down a stop or two. It all depends on the result you want. If your subject is fairly large, you might have to stop the lens down a bit to get the entire subject sharp — if you want the entire subject sharp. Often, a shot of a large subject is effective if only an interesting portion of it is sharp and the rest is out of focus.

The idea behind selective focus is to emphasize one portion of your image by making it sharp, so that it stands out from the rest of the image. The eye is naturally drawn to a sharp area in an otherwise unsharp picture. If a background is distracting, you can throw it out of focus so that it's not as distracting, and the eye will then be drawn to the subject.

For special-effect purposes, selective focus is most effective when there is a foreground object that can be thrown out of focus, so that your main subject is seen through it. Leaves, flowers, and other natural objects are ideal as fore-grounds for selective-focus images, but many manmade objects can be used as well. Sometimes you'll find just what you need at the scene. For example, if your subject is a beautiful flower, it might be surrounded by tall grass or other flowers that can be thrown out of focus by a large lens aperture, leaving only your subject's bloom in sharp focus. If you don't find what you need, devise it — gather some foliage, or hold a piece of colored cloth in the foreground.

Of course, you'll want to consider things like contrast and colors when choosing your subject/foreground combination. If you're shooting in black-and-white, you'll usually want a fairly dark subject and a light, airy foreground object. In black-and-white, think more in tones than in colors — a red subject shot through an out-of-focus green foreground might look great in real (color) life, but red and green tend to photograph as the same tone of gray in black-and-white, so the resulting photograph will likely just be a mass of muddy gray. You could use colored filters to produce some contrast in such a case. A red filter would lighten the red subject and darken the green, while a green filter would lighten the green and darken the red subject (probably the better option). You'll usually be better off selecting subjects that have natural contrast, that is, one that is considerably darker than the other.

In color, think color. If your main subject is quite colorful, perhaps you'll want a pastel-hued foreground to shoot through, so that strong colors don't fight each other for attention. If your main subject is not very colorful, a colorful foreground can add visual excitement to

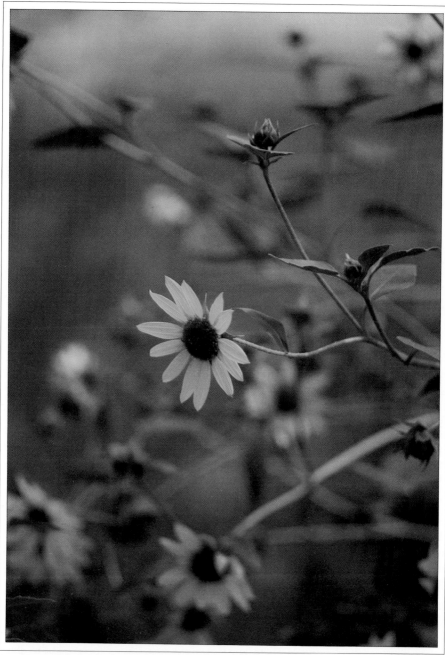

Combining selective focus with contrasting subject/background tones or colors is an effective technique. Use the camera's depth-of-field preview to check the effects of different lens apertures with your subject, then use the one that gives you the effect you want. Selective focus can make a subject stand out from its background, while the out-of-focus background still is sufficiently identifiable to show the subject's environment.

Out-of-focus images emphasize colors, forms, and broad textures, rather than the fine details of sharply focused images.

your image, but it also could fight with your main subject for the viewer's attention. There's no law that says you have to do it a certain way; just think about these things when you set up your shot, and make sure you don't ruin your image just because you weren't aware of them.

Your eye alone can't tell you what effect each lens aperture will produce in selective-focus work. If your camera has a depth-of-field preview, use that to preview the effect. If your camera has no depth-of-field preview, you can refer to the depth-of-field scale on the lens barrel, but depth of field is somewhat relative. The image doesn't suddenly go from sharp to unsharp at a specific point; rather it goes from sharp at the point focused on to gradually less and less sharp the farther from that point you go. You'll only get an approximate idea of the effect from the scale on the lens. Of course, any single-lens reflex

camera will show you in the viewfinder how much depth of field you have with the lens wide open, and since the lens will be wide open for most selective-focus work, the absence of a depth-of-field preview mechanism need not stop you from producing many fine images.

Sometimes you can produce an effective image by throwing the whole scene out of focus. Scenes containing many bright colors are particularly well suited to this effect. Here, the depth-of-field preview is a useful device, because you can control the degree of blur both by how far out of focus you set the focusing ring, and by the aperture you use. Generally, you'll want to shoot out-of-focus colors with the lens wide open, but not always. If there are bright highlights in the scene, they will take on the shape of the lens diaphragm if the lens is stopped down, and this is something to consider before committing the image to film. You can set the focus so that the

Out-of-focus light sources produce intriguing patterns of colored shapes. For maximum effect, the lens must be wide open. Don't be fooled by what you see in the viewfinder — what you see there is what you'll get only if the lens is set at its widest aperture, or if you use the depth-of-field preview at smaller apertures.

degree of blur looks good, then shoot with the lens wide open, and you'll get what you see in the viewfinder. Or, you can stop the lens down to a small aperture, set the focusing ring to throw the image further out of focus to compensate for the increased depth of field, and get diaphragm-effect highlights. For this, you should use the depth-of-field preview, because that's the only way you can see what you'll be recording when you push the shutter.

You can give those out-of-focus highlights various shapes by using cardboard "diaphragms" containing shaped apertures or by using mirror lenses, but these effects will be discussed later in the chapters on matte boxes and mirror lenses, respectively.

There are all kinds of things you can shoot through to produce selective-focus or out-of-focus images. Misty windows and falling rain, screen doors, lace or beaded curtains, textured glass — you

can probably find several useful items around your home. Keep in mind the variables when setting up your shot. When shooting a model through a screen door, for example, if the model is close to the screen, your image will contain a screen texture throughout. If the model is several feet behind the screen, and the camera is positioned very near the screen, the effect will be a diffused image if shot at a wide aperture. At a very small aperture, the screen might come into focus (you can see the effect by using the depth-of-field preview). How you light the subject and the foreground object, where you set the focus, how far the subjects are from the camera and from each other, and the aperture you choose all affect your image. If you consider all the variables and adjust them to suit your image, you'll get the image you want. If you ignore any of the variables, you might be in for a surprise when you see your picture.

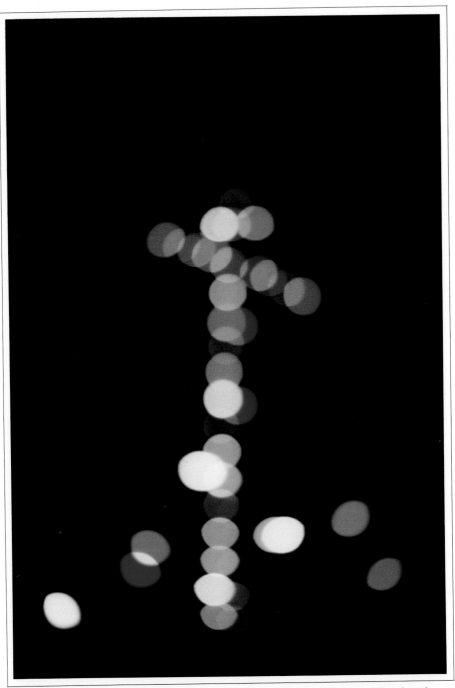

Out-of-focus highlights take on disk shapes with refracting ("ordinary") lenses (above), and ringlike shapes with mirror lenses (next page). Subjects were amusement park lights (above), and a busy boulevard (next page), both at night.

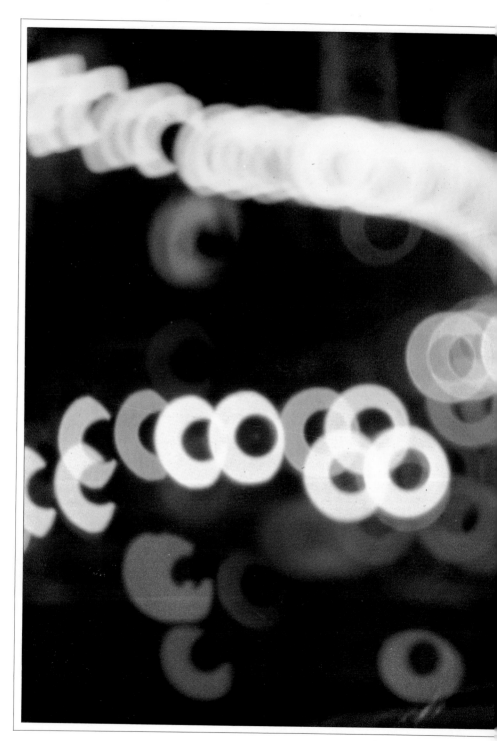

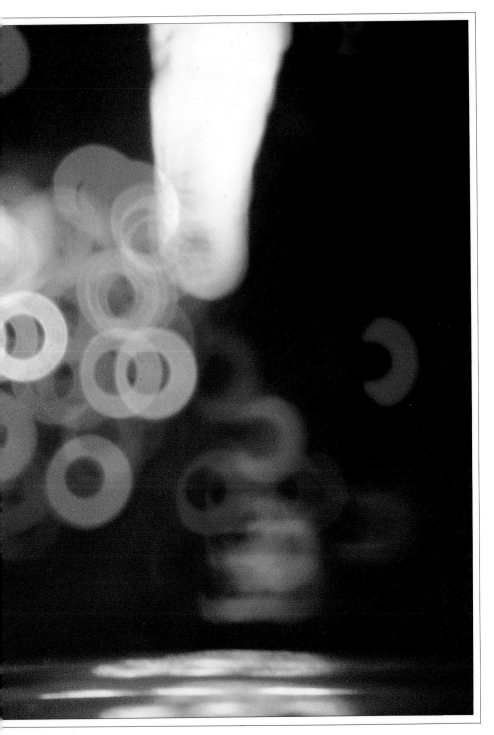

2
Shutter Effects

ONE FINE SOURCE OF SPECIAL EFFECTS IS your camera's shutter. You can use very short or very long exposures to produce images the eye can't see in real life.

While some shutter-related special effects can be produced with just about any camera, to do them all you'll need a camera with a B (bulb) or T (time) setting, plus a top shutter speed of 1/1000 second or shorter. On B, the shutter will remain open as long as you hold the shutter-release button down (you can use a locking cable release to keep the shutter open for really long exposures); on T, the shutter will remain open until you push the shutter button a second time. You'll also need a tripod for some long-exposure effects.

SHORT EXPOSURES

Very short exposure times — those no longer than 1/1000 second — will "freeze" moving subjects on your film. Shutter speeds of 1/1000 second will freeze most sports subjects sharply in your photographs. Shorter exposure times will freeze faster-moving subjects — Nikon's FM2 35mm SLR camera, with its 1/4000-second maximum shutter speed, can actually freeze a bullet in flight.

Even though you're using very short exposure times, you should still pan the camera when trying to freeze the action. Panning the camera means tracking the subject with the camera, much as a rifleman tracks a moving target through his scope. Frame the subject in the viewfinder before it gets to the point where you want to shoot it, track the subject, trip the shutter when the subject arrives at the chosen spot, and follow through. Don't stop tracking as you trip the shutter, or you might blur the subject. You'll find it handy to prefocus on the spot where you wish to shoot the subject, so you don't have to worry about focusing on the moving subject while also trying to pan the camera smoothly.

What shutter speed is required to stop which subjects? That's something you'll have to find out for yourself through practice and experience. Given the same rate of motion, a subject moving directly toward or away from the camera can be frozen with a slower shutter speed than one moving directly across the field of view. Most sports subjects can be frozen with a speed of 1/1000 second or even slower. With many subjects, you can shoot at the peak of the action — that moment when a jumper hovers motionless at the top of his leap before starting back down, for example — and still freeze the motion even with a relatively long exposure.

While shooting action subjects with fast shutter speeds will freeze them sharply, this isn't always the most effective way to make an action photograph, because such frozen action is static — both subject and background are frozen, and the feeling of motion is absent. Using a slower shutter speed (to be discussed shortly) will often produce a more effective action picture. Ultimately, you have to make the decision as to what the right shutter speed for a given subject is, based on your experience and desires.

In order to use super-fast shutter speeds, you'll have to use fast film in your camera. A 1/4000-second shutter speed with ASA/ISO 400 film requires a lens opening of f/5.6 in bright sunlight; if you're using a long and slow lens, or depth of field is important, or you're

working in dimmer light, you can see why fast film is essential. Any film-speed–increasing techniques you know will be useful here. Try pushing Kodak Tri-X to an incident-metered speed of E.I. 3200–4000, using Perfection XR-1 developer; the English Speedibrews Cel-er-Stellar and the more widely available Edwal FG7 are also good for getting maximum film speed out of black-and-white films. For color work, many custom processing labs will push E-6 films (Kodak Ektachrome 200 works well) one or two stops with good results.

Note: If your camera's fastest shutter speed is 1/500 second or longer, you can get frozen-motion effects by using electronic flash. See the chapter on electronic flash for details.

LONG EXPOSURES

If you photograph sports subjects but use longer shutter speeds (1/30 second or longer) and pan the camera to follow the subject's motion, you can produce exciting action photographs in which the panned subject is quite sharp but the background is completely blurred, thereby emphasizing the subject's motion and speed.

It takes some practice to become able to pan the camera smoothly and accurately, particularly when using long exposure times, but you'll soon become proficient if you work at it. The dynamic images you'll produce will make it all worthwhile.

Just as a fast film is needed for short-exposure effects, a slow film is helpful for long-exposure effects. If you use a fast film outdoors, you might not be able to slow the shutter speed down enough to produce the desired effect, even with the lens stopped all the way down. You can use a neutral-density filter to reduce exposure, but for optimum sharpness it's best to shoot with nothing in front of the lens, if possible. Even with a good-quality filter, it's just one

18

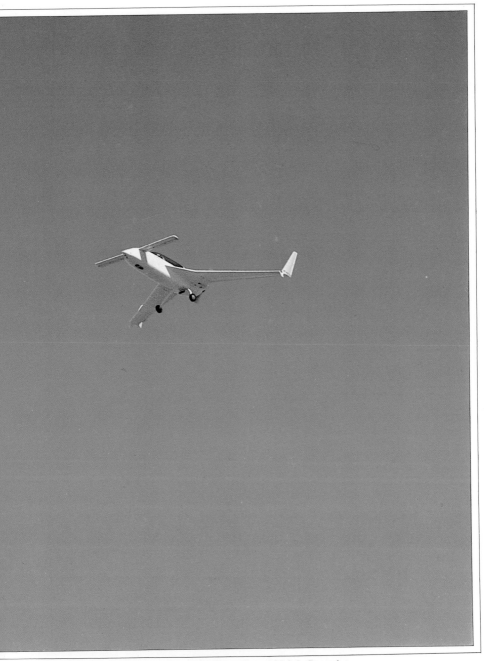

Short exposure times freeze the subject's motion, which is fine when the subject, and not its motion, is what you want to record. You know this airplane is moving because it's in the air, but the picture doesn't show motion because there is no blurred background for reference, and because the image is frozen by a short exposure.

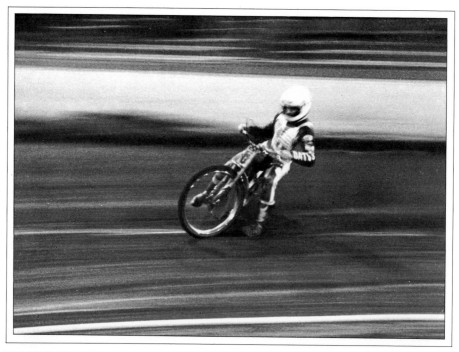

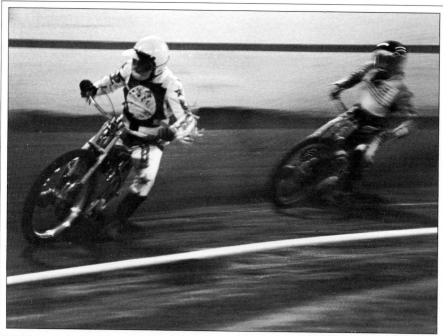

Panning with action subjects while using slow shutter speeds (here 1/30 and 1/15 second) blurs the background greatly and the subject to a lesser degree, really emphasizing the motion.

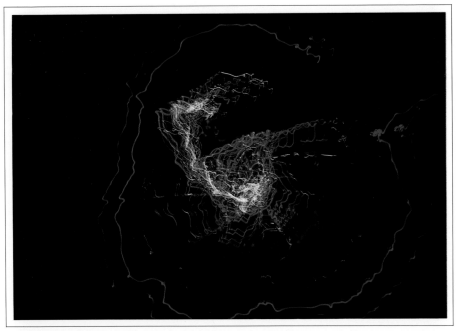

Moving the camera in circles or even randomly during a long (at least one-half second) exposure produces interesting abstract effects.

more piece of glass or gelatin the light must go through to reach the film, and one more piece of material to collect dust and smudges.

One thing to keep in mind when shooting panned action shots is that psychologically (so they tell us), action moving from right to left is more dynamic than action moving from left to right — presumably because we read from left to right, so action moving the other way is startling.

Sometimes an action image is more effective if the whole image is blurred, or if only the moving subject is blurred. To blur the whole scene, just pan a little more slowly than the subject is moving, while using a slow shutter speed. To blur only the subject, keep the camera still, and use a slow shutter speed — the subject's motion will cause it to blur, while the background remains sharp. It's a good idea to bracket shutter speeds when

trying for such effects, because each different shutter speed will produce a different degree of blur. Make sure you adjust the f-stop for proper exposure each time you change the shutter speed.

You can pan the camera in other directions than just horizontally to produce special effects with long exposures. In fact, you can move the camera in any direction that seems to suit your subject. You might want to try such effects as positioning a city skyline at night at the top of the frame and making a one- or two-second exposure, then panning the camera up to create blurred streaks from the lighted buildings. Or you could rotate the camera around the lens axis to get a circular, swirling effect.

Panning the camera during a long exposure can produce exciting effects with non-action subjects, too. The city skyline mentioned above is one example; another nice effect can be produced by

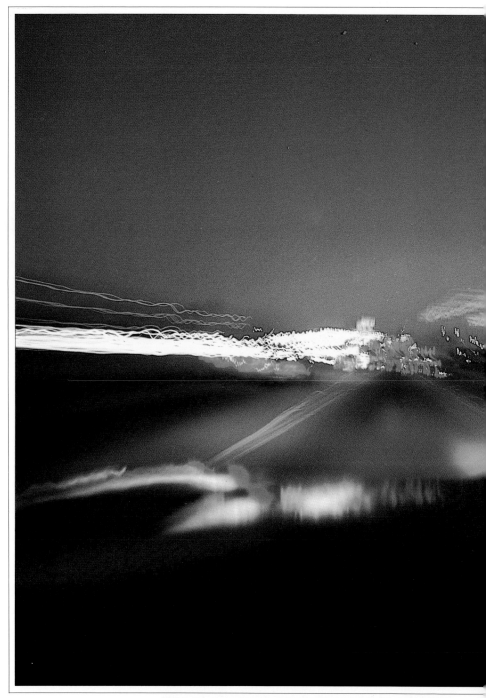

Making time exposures of two to 20 seconds while being driven down a street or freeway can produce a variety of effects.

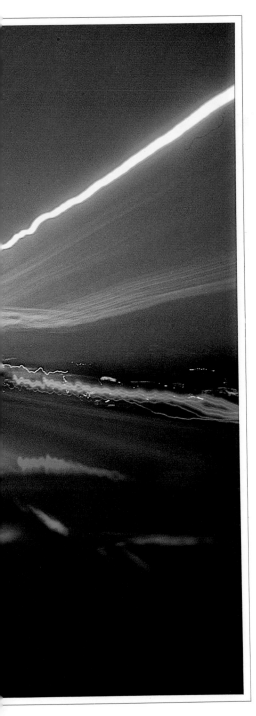

panning the camera across a garden of colorful flowers. As you experiment with these techniques, you'll undoubtedly come up with lots of new subjects to try them on, and will get some exciting, striking images.

Probably the simplest shutter-related special effect involves randomly moving the camera during a long exposure. In a darkened environment, such as an unlit room or outdoors at night, point the camera toward a light source (or several light sources of similar or varied color), open the shutter on B or T, and move the camera any which way. The image of the light source(s) will be traced on the film, producing abstract patterns. Try making several exposures this way, using different lights as subjects, and you'll come up with some interesting patterns. With a bit of planning, you can even "write" your name or a message on the film with this technique. It's an unusual way to make photographic Christmas cards. You can even have someone drive you down a brightly lit city street at night while you hand-hold the camera with the shutter open for several seconds for some unusual streak effects.

Of course, moving the camera during a long exposure is just one way to produce special-effect blurs. Another way is to keep the camera still, and let the subject's motion create the image. Good subjects for this technique are many: the aforementioned action subject, traffic on busy streets at night (the head- and taillights will produce brilliant streaks), waterfalls and waves at the beach (the water will take on a smooth cotton candy appearance), fireworks (point the camera at the area of the sky where the fireworks go off, and leave the shutter open for several bursts — you can do this with a tripod or hand-held for a variety of results), and star trails (point the camera skyward at night and make exposures ranging from 20 minutes to several hours) are some examples.

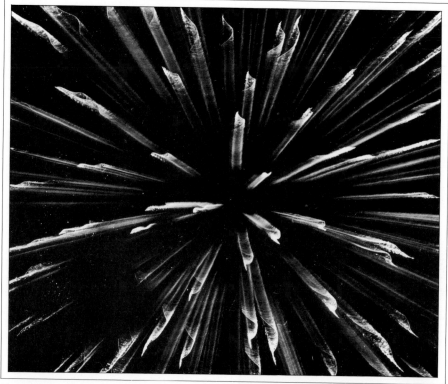

Hand-holding the camera during one-second exposures of fireworks produces abstract yet still identifiable images.

This technique is frequently used by architectural photographers to get pictures of buildings without people and cars cluttering the image. If you make a very long exposure of a building (using neutral-density filters to cut the light down sufficiently to permit the long exposures), the building will photograph normally, but transient people and cars will not be in any one spot long enough to register on the film. Don't try this at night, though; headlights and taillights will appear in the picture as streaks. Exposures of 30 seconds are usually long enough to eliminate cars and people from most street scenes, but it's a good idea to make a few longer exposures just to be safe. If you use slow film, you won't need so many neutral-density filters.

Physiograms are another variation on the long-exposure, stationary-camera technique. Suspend a penlight from a string attached to the ceiling, turn out all other lights in the room, set up the camera directly below the penlight, facing up, start the penlight swinging, and open the shutter on B or T. The penlight will act as a pendulum, producing fascinating geometric patterns on the film. You can use different colored filters over the lens, changing them during the exposure, to add color to the patterns. For a variety of results, try using normal and wide-angle lenses, different exposure times and lens apertures, different camera positions under the penlight (try turning the camera at a bit of an angle to the penlight, rather than having it

24

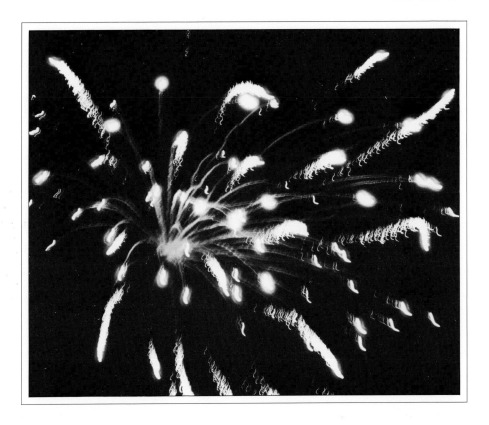

point straight up), using a multiple-image filter, shooting through a sheet of textured glass, or experiment with moving the camera sideways or rotating it around the lens axis.

Another long-exposure trick is to run a roll of film through the camera with the lens cap in place, so it receives no exposure; then open the shutter on B or T, and wind the film back through the camera with the rewind crank. All kinds of weird, elongated images can be produced this way, of both moving and stationary subjects. The exact aperture to use depends in part on how rapidly you rewind the film; start by winding the film at a rate of one turn of the crank per second, and use the aperture you'd use for a shutter speed of 1/2 second,

then bracket by using different apertures. Since the rate at which you rewind the film affects the degree of elongation of the image, it's a good idea to make several exposures of each subject, using different apertures and different rates of rewinding. You can speed up or slow down the rewinding rate to change the degree of elongation of the subject in different portions of the image. This technique calls for a lot of experimenting, but can produce some very unusual results.

RECIPROCITY FAILURE

When you're dealing with exposures shorter than 1/1000 second, or longer than 1/15 second, reciprocity failure must become a consideration. Actually,

One way to show motion is by using a slow shutter speed and keeping the camera still, letting the subject's own movement produce the blur. Effects will vary, depending on the subject's speed and the shutter speed used.

27

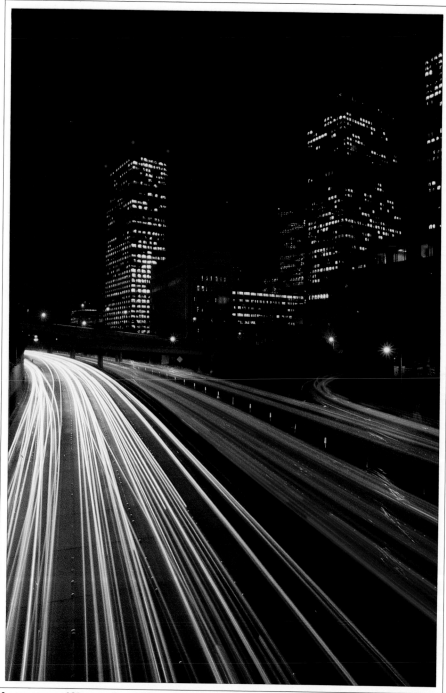

An exposure of 20 seconds at f/16 on Ektachrome 200 film turned auto head- and taillights into streaks, while a tripod held the camera steady to keep nonmoving subjects sharp.

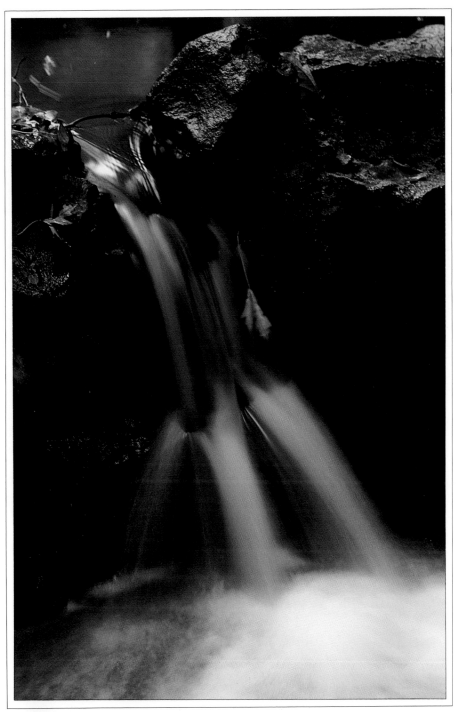

Exposing for times of 1/15 to one second will blur moving water into smooth, cotton candy forms.

29

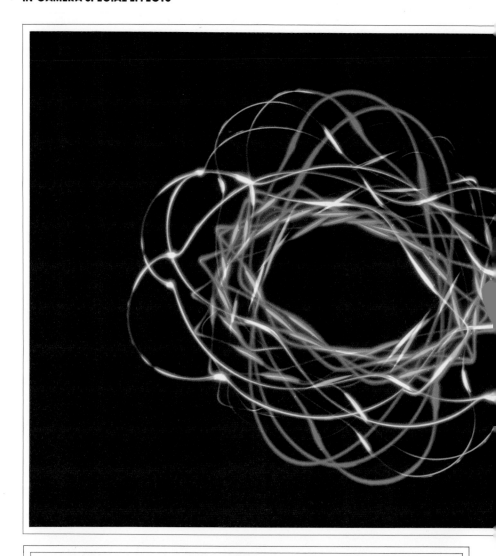

RECIPROCITY FAILURE COMPENSATION TABLE FOR B&W FILMS

Metered Exposure	Compensated Exposure	Reduce Development By
1 sec.	2 secs.	10%
5 secs.	25 secs.	15%
10 secs.	50 secs.	20%
30 secs.	250 secs.	25%
60 secs.	580 secs.	27.5%
120 secs.	1200 secs.	30%

Note: These compensations, while accurate, may not be exact for your particular film. Read the manufacturer's specifications on the film instruction sheet.

This physiogram was created by attaching a penlight to a string and letting it swing from the ceiling, while making an exposure of 15 seconds (in a darkened room) with the camera on the floor pointed straight up at the swinging light, its shutter locked open on B. To produce the colors, colored filters were held over the wide-angle lens during portions of the exposure time. Photo by Jim Zuckerman.

the correct term is "failure of the reciprocity law." The reciprocity law states that exposure is the product of the intensity and time of exposure. This means that an exposure of 1/250 at f/8 is the same as an exposure of 1/125 at f/11 or 1/500 at f/5.6.

For most camera films, the reciprocity law holds true for exposure times between about 1/15 and 1/1000 second. But at longer or shorter exposure times, the film doesn't respond quite so effectively to light — it loses speed, so you have to give more exposure than is called for by your light meter. The problem is compounded in color work by the fact that color films consist of three layers of light-sensitive emulsion, not all of which lose speed at the same rate, so that in addition to underexposure, you'll get a color shift if you use excessively long or short exposure times and do nothing to compensate.

Reciprocity data for specific films is available from the manufacturers on request, and is usually quite accurate for black-and-white films. The accuracy of color corrections suggested for color films tends to vary from emulsion batch to emulsion batch, however, so if precise color balance is critical in a very long or very short exposure shot, you should shoot a test, using a roll from the same emulsion batch as the roll of film you are going to use for the actual shot. Use the manufacturer's recommended exposure and filtration corrections, then examine the processed results, and decide what (if any) further corrections are needed. This testing isn't that critical with color negative films, which can be color-corrected during printing, but it is vital for color slide work.

The accompanying table will give you some rule-of-thumb reciprocity-effect exposure corrections for black-and-white work, but it's best to obtain specific data for a given film from the manufacturer.

3

Exposure Effects

EXPOSURE-PRODUCED SPECIAL EFFECTS CAN be created through overexposure, underexposure, and multiple exposures.

Intentional overexposure can produce a light, airy effect when such an effect is appropriate. It also increases the appearance of graininess in the image, produces good shadow-area separation and detail, and tends to merge highlight areas of the image. The effect is similar to high-key, except that true high-key images contain a small area (or areas) of true black, and overexposed images might not.

Deliberate underexposure can produce very rich colors with color slide films if not overdone (some photographers habitually rate Kodachrome 25 at speeds of 32 to 50 for this reason). It eliminates detail and separation in shadow areas, while producing good detail and separation in the brightest areas of the scene. The effect is somewhat like low-key, except that true low-key images generally contain a small area (or areas) of true white, while underexposed images generally don't.

Slight (one-half to one stop) over- or underexposure can enhance high- or low-key images, respectively, but high- and low-key images should be produced through proper lighting rather than through poor exposure.

MULTIPLE EXPOSURES

Some years ago, novice photographers messed up many of their pictures by making unintentional double exposures, because the cameras they used required two separate operations to cock the shutter and advance the film after each shot. To help these folks, the camera manufacturers started making cameras that incorporate both functions in one control, and so we have today's cameras, in which cocking the shutter lever also automatically advances the film to the next frame. Now novices rarely accidentally superimpose Spot's snout over Aunt Sally's face, but creative photographers who wish to deliberately make two or more exposures on the same frame of film may have some problems.

There are several cameras made today that permit in-register multiple exposures to be made, notably medium-format cameras with interchangeable film backs, and top-of-the-line 35mm SLRs. Some multiple-exposure techniques require precise registry, and you'll need a camera that can do it if you want to use these techniques. But many multiple exposures don't require precise registration, and these can be done with most 35mm SLRs by this method: Take up slack in the film by turning the rewind crank in the rewind direction until resistance is felt. Make the first exposure. Holding the rewind knob so it can't move, push the rewind button on the camera to disengage the film-advance mechanism. Operate the film-advance lever to cock the shutter, and make the next exposure. Continue this procedure until all desired exposures have been made on the frame, then put the lens cap on the lens, operate the film-advance lever, fire a blank shot, operate the film advance again, fire another blank frame, operate the cocking lever again, remove the lens cap, and you're ready to go again. (The second blank frame is required because sometimes the advance mechanism doesn't engage soon enough to advance a full frame the first time you operate the lever after making

the multiple exposures.) Cameras that have built-in multiple-exposure capability should be operated as per the instruction manual.

Note: If your camera doesn't permit making multiple exposures, you can do them in a darkened room with electronic flash and the camera shutter on B or T — see the chapter on electronic flash for details.

Now that you know the mechanics of making multiple exposures, you have to consider exposure. In normal montage-type multiple exposures, where one image is superimposed on another, each time you make an exposure the film receives more light. If you expose each image normally, the frame of the film will be overexposed. To prevent this, a simple method of exposure correction is to multiply the film's ASA/ISO speed by the number of exposures you intend to put on the frame, and expose each image accordingly. For example, if you're using ASA 25 film, and want to put four exposures on the frame, set your meter to 100 (ASA 25 × 4), and make each of the four exposures as per the meter reading.

If you want one image to be stronger than the others, give it more exposure, but make sure the total exposure given to the frame doesn't exceed normal exposure for the film.

For multiple exposures where the images don't overlap, give each image normal exposure.

Subject matter for multiple exposures is limited only by your imagination. Below are some ideas.

One useful multiple-exposure technique is the "see-through" image. Make one exposure of the subject with its outer covering in place, then make a second exposure with the cover removed. The result is a photograph that shows the subject's "innards" through its exterior. Automobile magazines often use this technique to show a racing car's

components through its body shell. Be careful not to move the subject or the camera between exposures, or your photograph will be out of register.

A related technique is the ghost image. Let's say you want to make a portrait of a man in his office, but you'd like it to be a little different. Shoot the man in his office, than make a second exposure on the same frame of film without the man. The office will show through the man, giving him a ghostly appearance — a good way to photograph a magician or an author of ghost stories.

You can use multiple exposures to put the sun or moon in a sunless or moonless scene. Just shoot the scene, and make a mental note (or draw yourself a diagram, if your memory isn't so good) of where the sun or moon should go. Then go out and shoot the sun or moon on the same frame, using a long lens to produce the desired image size. Don't try to put the midday sun into a shot this way; the technique works best with sunsets and moons. Caution: Never look at the sun through the camera — severe eye damage can result. Rather, hold a white card a few inches behind the viewfinder and use the sun's projected image on the card to compose the scene.

If you find it too time-consuming and inconvenient to shoot a scene and then try to find a suitable moon to add before going on to the next frame of film, you can shoot a whole roll of moons for future use. Make notes to help you remember where you put the moon on each frame, and how large it is. When the roll is complete, rewind all but the leader back into the cassette. Then, when you encounter a scene that needs a moon, just put your moon roll back in the camera, wind down to an appropriate moon, and make the exposure of the scene on that frame. To make sure things align properly, before you start shooting the moon roll mark a line on the film opposite a mark on the camera,

A slight (one-half stop) underexposure is a good way to retain highlight detail and produce saturated colors in transparencies.

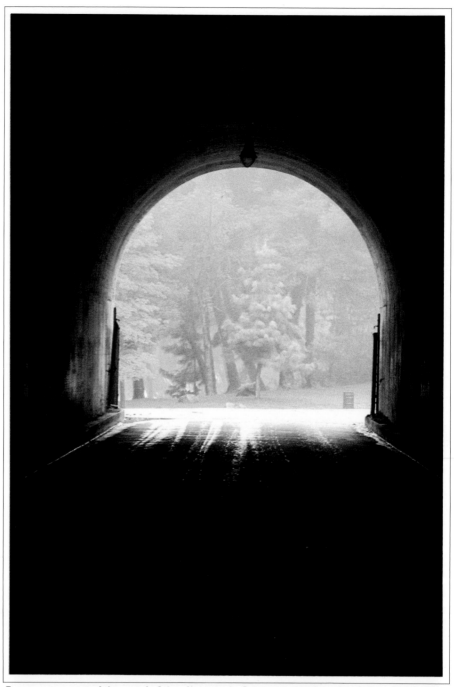

Exposure can control the mood of the photograph. Overexposure gives the picture above a light, airy feeling — "the light at the end of the tunnel" — while slight underexposure of the picture on the right gives a dark, rainy feeling that more accurately portrays the gloomy day.

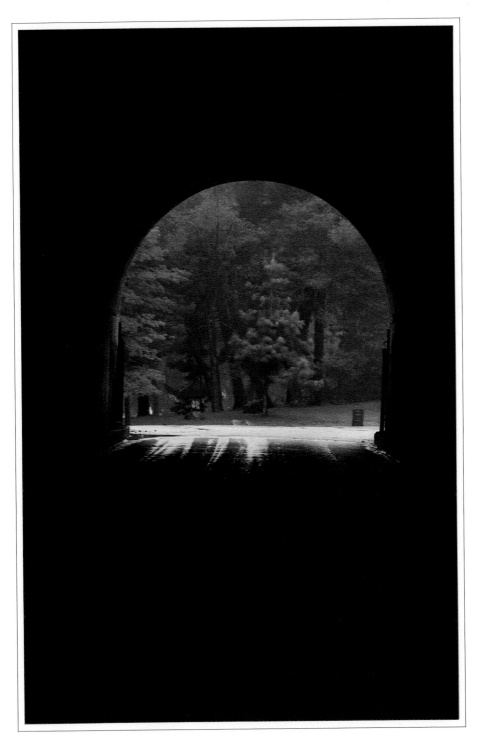

then close the back and shoot your moons. When you reload the roll, make sure the marks on film and camera body align, and you'll be in register (or close enough for most purposes). The correct exposure for the full moon on a clear night is the basic daylight exposure: a shutter speed of 1/ASA second at f/16 (1/125 second at f/16 with ASA 125 film). If you try to take a meter reading of the moon with a built-in camera meter, the meter will "see" a lot of black sky and call for way too much exposure, resulting in a burned-out white spot instead of a moon with detail. (If you like burned-out white spots for moons, you can use a paper punch to put a "moon" wherever you wish in your photos.)

Another useful multiple-exposure technique is the "night shot with detail" trick. Especially when shooting color, it's very hard to hold detail throughout a night scene that consists of lights and unlit areas. So, make one exposure of the scene just after sunset, while there is some light in the sky, to record detail in the unlit areas of the scene. Then, after it's good and dark, make a second exposure to record the night lights. You'll have to wait at least half an hour between exposures, so make sure the camera is solidly anchored before you start, and use a cable release to trip the shutter to minimize camera jiggle.

For a psychedelic effect to spice up slide shows, shoot several neon signs at night from different angles on one frame of film. The colors and perspective combine to produce eye-catching images.

One very effective multiple-exposure technique for portraits is to shoot a silhouette of the person, then expose a normally lit portrait over the silhouette. Since the silhouette is black, you can give the normally lit portrait normal exposure. You can use a head-shot silhouette with a head-shot portrait, or a head-shot silhouette with a full-figure

*Overexposing the rainy scene through a car windshield
produced this high-key effect with a hint of texture.*

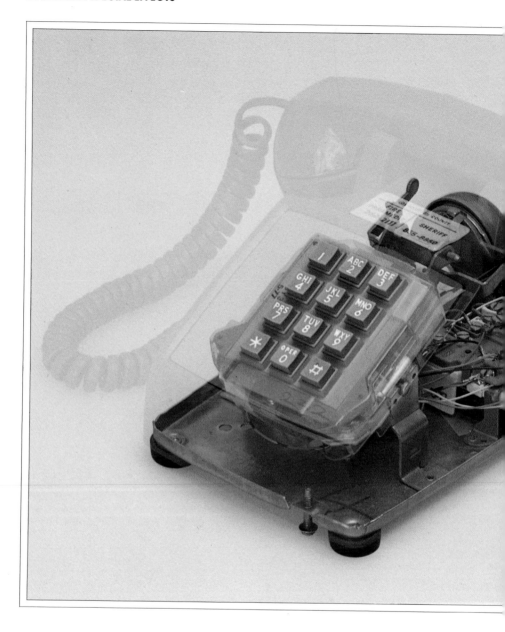

portrait, or any combination you desire. Think out the image before beginning, and decide on the best placement and size for each image. Drawing your idea out on a sheet of paper can be quite helpful. There are many variations you can use with this technique: Shoot a high-key face shot, and superimpose a normally lit full-figure shot at one side; shoot a low-key head shot and superimpose a normally lit full-figure shot in the shadow area; put straight-on and profile head shots into the same picture — you'll come up with good ideas of your own.

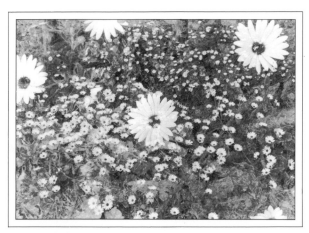

For this simple double exposure, a close-up of a few flowers was made first, using one stop less than normal exposure; then the camera was moved back, and a shot of the field of flowers was made, again using one stop less than normal exposure.

Two exposures on the same frame of film produced this see-through telephone. The phone was first shot with the cover off, using one-third stop less than normal exposure; then the cover was replaced, and the phone was shot using one stop less than normal exposure, so that the cover would appear as only a hint of form. The camera must be capable of making in-register multiple exposures for this technique; otherwise, the cover would be slightly off-register from the chassis.

For montage multiple exposures, you can superimpose a tight detail shot of a subject over an overall shot. Add flying seagulls to a seascape, superimpose the star of a play over an overall shot of a scene on stage — try any ideas you can come up with, and you'll learn and also get some effective images in the process.

Other multiple-exposure techniques are discussed later in the chapters on colored filters (including the spectacular three-filter technique) and matte boxes (putting the same subject in several places in a scene).

41

4

Flare, Reflection, and Shadow Effects

LENS FLARE IS CAUSED BY EXTRANEOUS (I.E., non-image-producing) light striking the front element of the lens. This light then bounces around inside the lens and off the surfaces of the other lens elements, destroying contrast and washing out the image. To help minimize the effects of flare, lens makers apply antiflare coatings to lens elements, and image-ruining flare isn't the problem it once was with older uncoated lenses. But it's still possible to produce flare when you want it, and doing so can yield some striking special-effects images.

Flare is produced whenever direct rays from a light source strike the front element of the lens. You can produce flare by including a light source in the image frame, or by aiming the camera so that the light source is just out of the frame, but its rays still strike the front lens element. How do you know what effects you'll get? If you use a 35mm SLR camera, you can see them in the viewfinder. With other camera types, you'll just have to apply what you learn in the next few paragraphs to make an educated guess as to what you'll get on your film. It's definitely best to use a single-lens reflex camera for flare-effect shots.

Flare comes in two forms: flare spots, and an overall glare. The flare spots are smallest and sharpest at small lens apertures; they grow larger and less precisely defined as you open the lens. Flare spots are most evident when the light source is either in the frame or right at its edge, half in and half out of the picture. Overall flare occurs whenever direct light strikes the front of the lens, and is most evident when the light source is just out of the frame, and at large apertures.

By adjusting the lens aperture (and checking the effect with the camera's depth-of-field preview) and the light source's location in or out of the frame, you can control flare and flare spots to some degree, putting the spots where you want them in the image.

Since flare occurs basically in backlit conditions, expose accordingly. Either take an incident-light reading, with the meter's translucent hemisphere pointed at the camera, or open up two to three stops from a reflected-light meter's recommendation. If you expose according to a reflected-light reading, the flare will cause the meter to call for too little exposure. It doesn't hurt to bracket exposures (and apertures, for effect) when you first work with flare; you'll soon learn how to produce results that suit your taste.

You can produce a different sort of flare effect by backlighting your subject with a large light source, such as a picture window or a large, diffused studio lamp. The backlight will "wrap around" the subject from behind, lighting its edges but leaving the center unlit. If you base the exposure on an incident-light meter reading taken right in front of the subject, with the meter's translucent hemisphere pointed at the camera, you'll get a strong flare effect. If you'd like a softer effect, add some frontal lighting on the subject, using a light or a white reflector, and base your exposure on an incident-meter reading as before. You can control the effect by adjusting the strength of the frontal lighting—more for a softer effect, less for a harsher effect—always using an incident-light meter to determine the exposure. Note: This effect is not terribly flattering for people subjects.

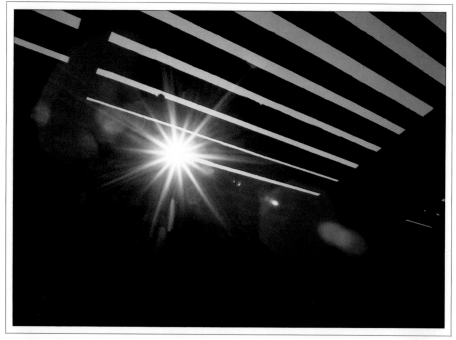

Shooting with the lens aperture wide open produces the greatest flare effect, as seen in the

To get another effect, base the exposure on a reflected-light reading of the backlight. The result will be a silhouetted subject with background flare.

REFLECTIONS

Reflections make fine special-effects subjects. The main skill you need to record them is the ability to see them. Look for reflections when you go out to shoot, and even when you go out for other reasons. Mirrors, windows, wet streets, water, polished floors, and other shiny surfaces all produce reflections, and merely by learning to notice them, you'll find all sorts of exciting subject matter.

To shoot the reflections, take a reflected-light reading of the reflection, focus on the reflection (rather than on the surface on which it appears), and bracket. Try shooting from different angles — but look first. From some

angles, the reflection will disappear.

For variety, you can focus on the reflecting surface rather than on the reflection. This will throw the reflection out of focus, but leave the reflecting object sharp. Try different apertures to vary depth of field, and you'll likely get several different but interesting images.

You can use a polarizing filter to control the reflection to some degree. If the reflection is from a nonmetallic object, the polarizing filter can reduce or eliminate it, depending on the angle at which you're shooting and on the orientation of the polarizing filter. Rather than get too concerned about angles of incidence and reflection and the like, just look at the scene through the polarizer, and turn the filter until you see an effect you like. Then mount it on the camera lens in the same orientation, and you'll get what you saw on your film. If you're using a single-lens reflex camera,

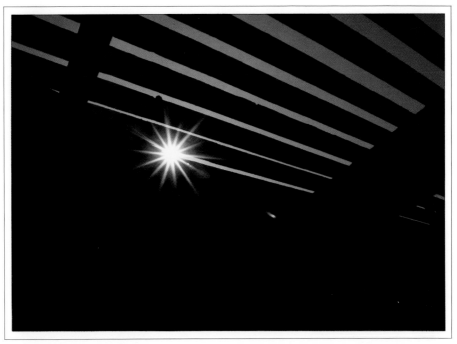

picture at left; stopping the lens down (here, to f/16) produces less flare, as seen above.

you can do all of this with the filter on the lens, just by looking through the viewfinder. The filter factor for a polarizing filter is 2.5 (divide the film's ASA/ISO speed by 2.5 and set this figure on your light meter, or open the lens 1⅓ stops from a meter reading taken with the ASA dial set for normal film speed). Don't use a through-the-lens camera meter to read through the polarizer, because some of these metering systems will produce erroneous exposure information with polarized light.

If your reflections are in water that is moving, such as reflections of store signs in the ocean near a pier, try using different exposure times. Short exposures will "freeze" the reflected image, while longer exposures will blur it. Both versions — frozen and blurred — will be interesting.

Often, close-ups of a portion of a reflection produce fascinating images, so each time you find an interesting reflec-

tion, investigate it from various shooting distances.

You can make an unusual series of self-portraits by shooting reflections of yourself with camera in various reflecting surfaces, but you'll generally want to keep yourself out of the picture. To do this, just shoot at an angle rather than from directly in front of the reflection. You can see yourself in the reflection if you're in it (if you look for yourself, that is — don't become so fascinated by a reflection that you don't notice your own image in there with it). If you see yourself, and don't want to, move.

If you get tired of "found" reflections, or want to get more creative, you can obtain some Du Pont Mylar material. This is a chrome-coated film that comes in large rolls, and can be purchased by the yard. It also comes in colors, although the silverish chrome Mylar can be colored by using filters.

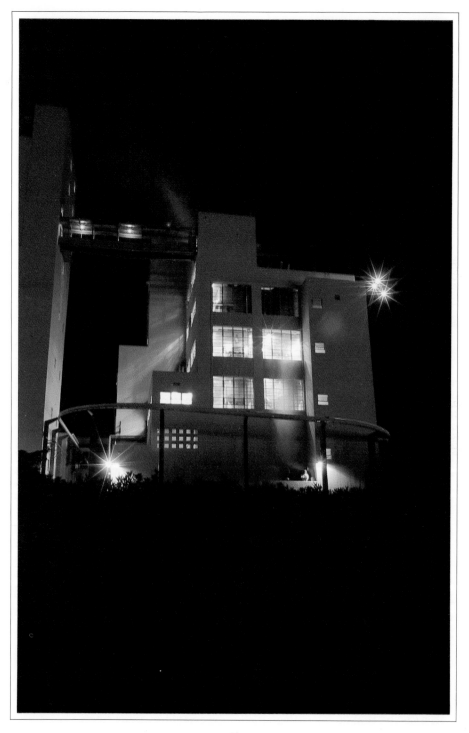

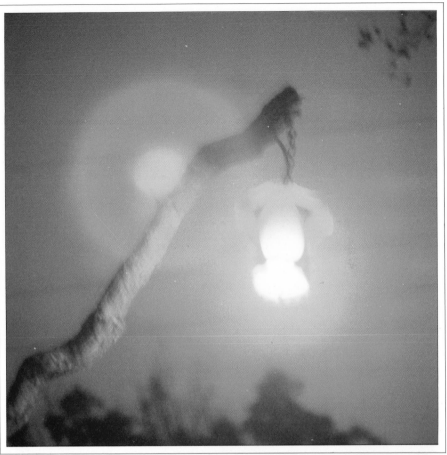

Throwing the subject out of focus produced a soft, round flare spot here. Use your depth-of-field preview, and experiment with different focus settings when using flare for effect.

Any time light sources appear in the picture, flare can occur. Watch for it and put it to work for you, or select another shooting angle to eliminate it, if you don't want flare in the photograph.

47

Many modern buildings have highly reflective surfaces, and are good sources of interesting reflections. Move around and look at the reflections from different angles to find the most effective shots. Consider including a portion of the building and its environment along with the reflections for added interest.

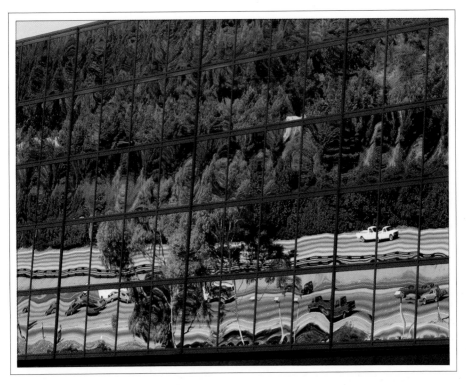

Mylar is highly reflective. In addition, it is easy to curl, bend, and fold into any number of positions, each of which will distort its reflections in interesting ways. Just lay out the Mylar on the floor, position a subject so that it is reflected in the Mylar, light the subject to your liking, meter, and shoot. Then curl, bend, and fold the Mylar into another configuration, and shoot the new reflected image.

To get the whole reflection sharp (and this is the case with any reflection shot at an angle), you'll have to stop the lens down so that depth of field is sufficient for the task. The camera's depth-of-field preview is quite useful in letting you see just what your reflected image looks like at a given f-stop. In order to stop the lens down, you'll have to light your subject brightly (electronic flash used close to the subject is a good light source) and/or use fast film. You can

shoot frames at different apertures for variety. Remember to consider close-ups as well as full-reflection shots.

Try using Mylar outdoors. You can't put the sun right where you want it all the time, but you can orient the Mylar, your subject, and your camera relative to the sun to achieve desirable effects. A lot of flare from the brightly reflected sun, and winds disarranging the fragile Mylar, are good reasons to do most of your Mylar work indoors, however.

Flat or photographer-warped surfaces aren't the only source of good reflections. Reflections appear in all shiny surfaces, including those of silver goblets, glasses, polished automobiles, hubcaps, prop spinners on airplanes, and doorknobs. Keep your eyes open and your mind alert, and you'll find all kinds of reflections to shoot.

Reflections can be incorporated into combined images, as well as shot alone.

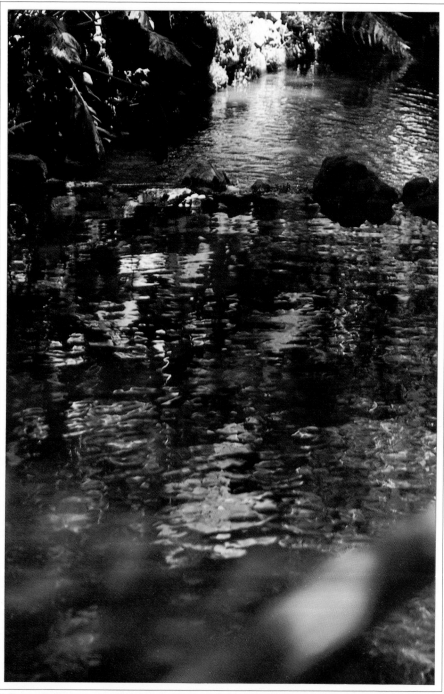

Foliage reflected in a pond produces green highlights. This shot would have been gray and dull in black-and-white—another thing to think about when contemplating a shot.

This self-portrait is an interesting example of the strangely distorted reflections Mylar can produce. Photo by Jim Zuckerman.

The old cliché portrait of the prison guard with the prison yard reflected in his mirrored sunglasses is one example. If you choose the right angle and lighting, you can record reflections in a store window and what lies behind the window as well. Another interesting effect is to shoot a glassed, reflective building, including the whole building and the unusual mosaic reflections of its surroundings in its glass surfaces.

SHADOWS

Shadows are another bountiful source of special-effects material. Shadows of objects, shadows on objects, interplay of light and shadow, silhouettes — all make for visually exciting images, and all you need to do is practice looking for them.

As is the case with reflections, you can use "found" shadows — those you just happen to come across — or created shadows — those you produce for a specific effect. You can create striking images using either type.

Some of the most effective naturally occurring shadows are the long ones produced by the early morning and late afternoon sun. Landscapes, buildings, trees, and picket fences are among the subjects that produce fascinating shadows when the low-angle sun strikes them. You can shoot only the shadows, or you can include the object(s) producing them — the long shadows help emphasize the texture and form of the objects in the scene.

Other nice sources of found shadows include people almost anywhere, but especially outdoors on a sunny day, automobiles on highways, and trellises, trees, and other objects that cast intricately patterned shadows.

Look for shadows everywhere — on the ground, on walls, on objects. Ansel Adams shot a wonderful image of a tree shadow on a large rock that most of us would have walked right past and never even noticed. Just as with reflections,

once you get your mind accustomed to looking for shadows, you'll start to notice them automatically.

Silhouettes are subjects in shadow. They can be produced in the traditional way, by backlighting the subject and exposing for the bright background so that the subject is underexposed, but there are other ways to do it as well. You can position your subject near a light-toned wall and use a spotlight to project its shadow on the wall, then photograph the shadow. Or you can set up a translucent background material, position the subject behind it, shine a light on the subject from behind so that its image falls on the translucent material, and then photograph the silhouette on the material.

Created shadows can be produced by putting various shadow-producing objects between your subject and the light source. Try various ornamental gratings or Venetian blinds. Anything that will cast an appropriate shadow pattern on the subject can be used.

You can use several light sources around your subject to cast several shadows, and then photograph the whole scene or just the shadows. One really special shadow effect involves the three-filter technique completely discussed later in the chapter on colored filters. Put a light source to the subject's left, and shoot (on color film) through a red filter; then move the light to the subject's right and shoot through a green filter; then move the light in front of the subject and shoot through a blue filter, all on the same frame of film. The result will be a subject in natural color, with three colored shadows. A variation on this theme is to shoot a sunlit subject through each of the three filters, waiting long enough between exposures for the sun to move sufficiently to cast a differently positioned shadow. Again, you'll get a subject in natural color, with colored shadows surrounding it.

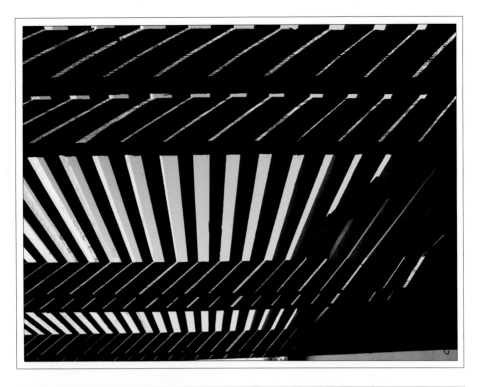

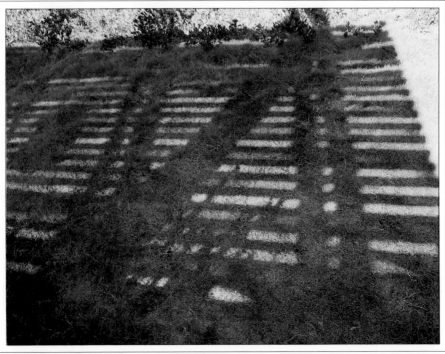

One set of shadows can produce a wide variety of effects. The framework makes an interesting study in light and shadow (top), and its shadow on the ground provides another image (bottom).

53

Silhouettes are shadows, or unlit subjects. They can be interesting because of what's behind them, as well as for their own shapes. Here's a silhouette/water reflection combination. The same lighting that produces silhouettes (backlighting) also produces bright reflections on the water's surface. Both can be recorded nicely using the basic daylight exposure (shutter speed of 1/ASA at f/16, or the equivalent shutter-speed/aperture combination). The exposure here was 1/250 second at f/16 on Tri-X, rated at E.I. 250.

Look up as well as around you for interesting patterns. Shooting up through trees produced a pattern of light and dark that is interesting because of the contrast.

5

Film Effects

SEVERAL FILMS, ALL FROM KODAK, HAVE special effects built in. All you need is your camera and one of these films, and you'll get some sort of special effect.

Kodak's special-effect films include Recording Film 2475 for grain effects, Technical Pan Film 2415 for sharp high-contrast images in black-and-white, and High Speed Infrared (black-and-white) and Ektachrome Infrared (color) for infrared effects.

KODAK RECORDING FILM 2475

Kodak Recording Film 2475 is the fastest, grainiest, and least sharp 35mm film readily available. It comes in 36-exposure 35mm cassettes (Kodak catalog number 163 2033) and 125-foot bulk rolls (catalog number 179 3892). Most large photo stores stock the cassettes; if yours doesn't, the store can order the film for you from Kodak, using the appropriate catalog number.

Originally developed for low-light police surveillance work and scientific recording, 2475 doesn't actually have an ASA/ISO speed, but can be rated at E.I. 1000–1600 for most pictorial work, and as high as E.I. 4000 (with a 50-percent increase in development) for dimly lit low-contrast scenes.

For pictorial work, set your light meter's ASA index to 1000–1600, expose the film accordingly, develop it (or have it developed) in HC-110 or DK-50 developer as per the directions that accompany 2475, then make the prints (or have them made) on soft (low-contrast) paper to minimize the grainy appearance. Suitable 8 × 10-inch prints can be made in this way, but use 2475 for pictorial work only when you need its extreme film speed, chiefly because its resolution is

considerably lower and its grain considerably larger than what you're used to in everyday photographs.

For special grain effects, set your meter to E.I. 1000–4000, expose the film as per the meter in the usual manner, develop the film 50 percent longer than normal, and make the prints from just a section of the negative using contrasty (grade 5) paper to emphasize the grain.

Naturally, because 2475 has such large grain and low resolution, it's best to shoot subjects with large areas of form, rather than those with fine, intricate details that would be lost in the grain.

Due to its unique characteristics, Recording Film 2475 requires several special considerations in use and handling. First, it has extended red sensitivity, which is handy because the dim scenes it's usually used for are generally illuminated by reddish manmade light sources. But the effect is similar to that of shooting standard black-and-white film through a red filter: red and yellow and flesh-colored subjects are reproduced lighter than you'd expect. Keep this characteristic in mind if your subject is a fair lady, for she'll photograph ashen with white lips on 2475.

Since 2475 is so fast (another way of saying it is very sensitive to light), it should be loaded into the camera, and unloaded as well, in subdued light — never in bright sunlight.

If you do your own processing, you should be aware of a couple of things. Use an acid stop bath, not just a water rinse, between the developer and the fixer, or a dichroic fog will form on the film, diminishing image quality. The Estar-AH film base tends to curl rather severely when you cut the dried roll into

If you want large grain in your image, Kodak's Recording Film 2475 is just what you need. It's the grainiest film readily available, and all you need do to produce grainy photos is expose it at E.I. 1000–4000, develop it per the directions, and print it on normal-contrast or harder paper. While high contrast generally is not ideal for people-pictures, combined with 2475's grain, it works well in this portrait of model Denise.

This portrait of model Duchess shows the soft side of 2475. It was produced by positioning the model in front of a large picture window, using a large sheet of white poster board next to the camera to provide fill lighting, exposing the film at E.I. 1000, and developing it normally in Kodak HC-110, and printing a small section of the negative on soft paper.

strips for proofing and storage. About the only way you can proof it is to use thin strips of tape to hold the film to the cover glass of the proof-printing frame, then lower the glass over the paper.

KODAK TECHNICAL PAN FILM 2415

Technical Pan Film 2415 is the antithesis of Recording Film 2475. Tech Pan is an extremely sharp, extremely fine-grain, and rather slow emulsion that shares only one special characteristic with 2475: extended red sensitivity. Tech Pan can be used for pictorial work when high film speed is not important but huge blow-ups are. It can be rated at E.I. 12–160 for pictorial work, depending on the developer you use to process it, and on how much shadow detail you require. If you have a good lens and attach the camera to a tripod, you can blow up 35mm Tech Pan negatives to 20 × 24 inches and even more with amazingly fine grain and great sharpness. Kodak's Technidol LC developer is made especially for pictorial work with Tech Pan; Perfection XR-1 and VXR developers can also be used with good results.

For special-effects purposes, Tech Pan's forte is contrast. Bracket exposures around a reading made with your meter's ASA index set for 100, and develop the film in Kodak D-19 developer for four minutes at 68°F, and you'll get sharp, fine-grained negatives contrasty enough to print as only black and white tones (no intermediate grays) on grade 5 or even grade 4 paper.

If you process the film youself, don't panic when your first solution pours out of the tank black. This is normal with Tech Pan — I believe it's an antihalation dye that is no longer needed after exposure. Also, Tech Pan shares 2475's thin, stable, and very curly Estar-AH base, but it doesn't seem to curl as badly as 2475 when cut into strips for proofing and storage.

When exposed at ASA 25 and processed in Kodak Technidol
LC, or exposed at E.I. 80 and processed in Perfection XR1 (this
shot was produced with the E.I. 80/XR1 combination), Kodak
Technical Pan Film 2415 produces incredibly sharp, remarkably
fine-grain, continuous-tone images. Thus treated, Tech Pan can
be used for pictorial photography whenever very large (up to 30
× 40 inches from 35mm negatives) blowups are required. Tech
Pan's sharpness, grainlessness, extended red sensitivity (which
helps cut through atmospheric haze) and crisp contrast suit it
well for aerial photography.

Kodak Technical Pan Film 2415 is available in 36-exposure 35mm cassettes (Kodak catalog number 129 7563), 125-foot 35mm rolls for bulk-loading buffs (catalog number 129 9916), and 50-sheet boxes of 4 × 5-inch sheet film (catalog number 152 4594).

KODAK HIGH SPEED INFRARED FILM 2481

High Speed Infrared 2481 is a black-and-white film emulsion that is sensitive to ultraviolet, blue, red, and infrared wavelengths, but not to most of the middle of the visible spectrum (the cyan, green, yellow, and orange wavelengths). For scientific use (which was the film's original purpose), a Kodak Wratten No. 87, 87C, or 88A filter can be used to block out all visible light wavelengths, permitting the photographer to make photographs by infrared radiation alone. For special-effect pictorial use, it's best to use a filter that transmits some visible radiation as well, such as the red Wratten No. 25.

Jet-black skies, white foliage, high contrast, large grain, a lot of flare around hot subjects, and excellent haze penetration are High Speed Infrared's points of major interest to the special-effects photographer. Human skin reproduces very pale, and veins can be seen under the skin. Eerie is probably the best single word to describe black-and-white infrared photographs.

Since light meters don't measure infrared radiation, and the amount of infrared radiation coming from a scene relative to the amount of visible radiation varies from scene to scene, ASA/ISO speeds are somewhat irrelevant when you're working with infrared-sensitive film. With the red No. 25 filter over the lens, bracket two stops around a base exposure of 1/125 second at f/11; for nearby scenes, bracket around 1/30 second at f/11 — these figures assuming a "standard" clear, sunny day. The best

thing to do in other circumstances is take a reading with your meter, setting its ASA dial to 50 outdoors or 125 for tungsten lighting, and bracket three stops each side of the meter's recommendation. If you keep notes each time you shoot, you'll soon know how to get a good exposure.

Aside from its special image qualities, High Speed Infrared offers a couple of other oddities. First, the camera must be loaded in total darkness, so take a changing bag along if you intend to shoot more than one roll at a session. Second, it's out of focus if you focus in the usual manner. Camera lenses don't focus infrared wavelengths on the same plane as visible wavelengths, so you must compensate for this when using infrared film. This is fairly easy to do with most lenses; just use the infrared focusing mark, which usually takes the form of a red dot, not too far from the standard focusing index. Just focus on your subject in the usual manner, then turn the focusing ring so that the focused-upon distance moves from the standard focusing index to the infrared focusing dot. It's also wise to stop the lens down as far as possible, to help minimize focusing errors.

Kodak High Speed Infrared Film 2481 is available in 36-exposure 35mm cassettes (Kodak catalog number 169 2086), in 100-foot 35mm rolls (catalog number 160 4149), and, under the designation 4143 rather than 2481, in 25-sheet boxes of 4 × 5-inch sheet film (catalog number 171 3015).

KODAK EKTACHROME INFRARED FILM 2236

Ektachrome Infrared 2236 is a 35mm color slide film that produces very strange colors. Normal color films contain three emulsion layers, respectively sensitive to red, green, and blue light wavelengths. Ektachrome Infrared film's three emulsion layers are sensitive to

For extreme contrast effects, expose Tech Pan at E.I. 100 (bracket exposures until you get a feel for the film) and develop it in Kodak D-19. Prints on grade No. 4 or 5 paper will have only black and white tones, with no in-between grays.

Kodak's black-and-white High Speed Infrared film, when exposed through a red No. 25 filter, yields grainy, contrasty, and eerie results. Skies and water generally turn black, and foliage usually comes out white in prints, but not always—it depends on how much infrared radiation is present, and about the only way to find that out is to shoot a picture with infrared film.

red, green, and infrared wavelenths. For scientific work, a yellow Wratten No. 12 filter is used to block out the blue wavelengths to which all emulsions are sensitive. For special-effect pictorial work, several colored filters can be used to produce various and sundry results that are not entirely predictable.

Using a yellow Wratten No. 12 or 15 filter, and bracketing exposures around a meter reading at ASA 50, you'll generally get slides with pinkish foliage, cyan skies, and somewhat cyan skin tones.

A red No. 25 filter, coupled with exposures bracketed around a meter reading at ASA 50, will generally yield green skies, orange foliage, and yellowish skin.

For deep blue skies and magenta foliage and skin, try a green No. 58 filter, bracketing exposures around an ASA 20 meter reading.

Since the general idea behind infrared photography is to get rid of blue wavelengths, it would seem folly to use a deep blue filter with Ektachrome Infrared, but if you're so inclined, you can try a blue No. 47 filter, bracket around an ASA 10 meter reading, and you'll likely find pale to intense red foliage, reddish skin tones, and white skies.

Since two of Ektachrome Infrared's three image-forming layers are sensitive to visible light wavelengths, you don't have to use the lens's infrared focusing mark when using this film; nor do you have to load and unload the camera in total darkness — subdued light will do. However, Ektachrome Infrared should be stored at $-10°$ to $0°F$ ($-23°$ to $-18°C$) until you're ready to use it, while black-and-white High Speed Infrared can be stored at $55°F$. When you're ready to use your Ektachrome Infrared, let it warm up to room temperature before you open the container.

Ektachrome Infrared is really a surprise film — you'll never really know ahead of time what your picture will look like, because you never know how

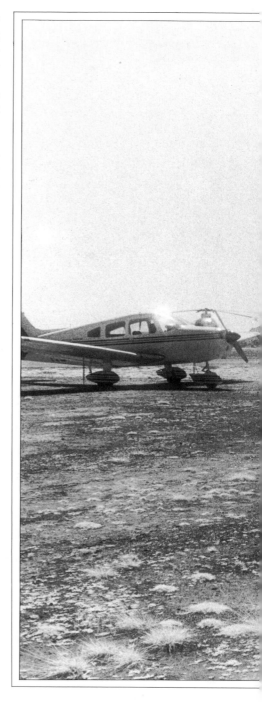

*Infrared radiation is heat, and hot objects give off a lot of it,
causing flare in infrared photos. The shiny metal airplane in the
sun emits a lot of infrared, hence the intense flare.*

much infrared radiation is present. Even if you had a device that would tell you the ratio between the visible wavelengths and the infrared ones, it wouldn't be worth the time of the special-effects pictorial infrared photographer to then try to figure out how this will affect each emulsion layer of the film, and what that would mean in terms of an image. If you're interested in playing with such things, the yellow positive image is formed in the green-sensitive layer of the film; the magenta image is formed in the red-sensitive layer, and the cyan image is formed in the film's infrared-sensitive layer. Different breeds of foliage give off different amounts of infrared radiation, and different individuals within a given breed of plant give off different amounts of infrared radiation when in different states of health. For most of us, it's best to use the guidelines given a few paragraphs back — bracket exposures, keep notes, and be surprised.

Kodak Ektachrome Infrared Film 2236 (catalog number 168 5718) is available in 36-exposure 35mm cassettes at most photo stores.

SPECIAL EFFECTS WITH NORMAL FILMS

You can produce several special effects using normal, everyday films. If you shoot daylight-balanced color film by tungsten lighting, your images will have a warm, orange cast. Conversely, if you shoot tungsten-balanced color film in daylight, your images will have a cool, blue cast — good for snow scenes.

Another way to obtain odd images with normal film is to project or have printed your color negatives. These have an orange cast that can enhance some images. You can eliminate the orange cast during projection or printing through filtration if you wish to do so. Subjects with bold colors are the best kind for negative-image color effects; pale colors aren't as effective.

Color infrared film, in the form of Kodak Ektachrome Infrared, is sensitive to infrared as well as visible radiation. It therefore produces strange and somewhat unpredictable colors. Colored filters can be used to produce a variety of effects. The results shown here were obtained with no filter (opposite, top), a yellow filter (opposite, bottom), a red filter (page 68, top), a blue filter (page 68, bottom), and a green filter (page 69, top). Because infrared film is so unpredictable, bracket your exposures (the shot on the bottom of page 69 was overexposed using a blue filter). Ektachrome Infrared requires the old E-4 process, not the current E-6 Ektachrome process. The film must be sent to a central Kodak plant for processing. That the film might be exposed to heat en route only adds to the surprise.

6
Colored Filter Effects

YOU CAN USE COLORED FILTERS TO PRODUCE special effects in both color and black-and-white photography. When working in black-and-white, colored filters alter the relative lightness and darkness of the various colored objects in a scene. In color work, colored filters can enhance existing color, change the mood of a scene, and produce magical colors.

BLACK-AND-WHITE PHOTOGRAPHY

When used properly in black-and-white work, a colored filter has the effect of lightening objects similar in color to itself, and darkening those of its complementary color, in the resulting print. For example, a red filter will lighten red objects (and to a lesser degree, yellow and orange ones) while darkening cyan objects (and to a lesser extent blue and green ones).

Why would you want to lighten or darken particular objects in a scene? Generally, to increase the resulting photograph's impact. A blue-cyan sky can be darkened with a red filter, so that puffy white clouds stand out dramatically in a scenic shot. A color photo of shiny red ornaments on a fresh green Christmas tree has impact because of the contrasting colors. But both red and green subjects reflect about the same amount of light, so they appear as about the same medium shade of gray in a black-and-white photograph. Use a red filter, though, and you'll get bright white ornaments against a dark tree. Or you could use a green filter, to get dark ornaments against a lighter tree.

Another good use for colored filters is reducing haze in scenic or other distant shots. Haze in the air scatters the light,

which is what causes the "hazy" appearance. The short ultraviolet and blue wavelengths are scattered most; the longer red and infrared wavelengths are scattered least. A yellow or red filter will absorb most of the short, greatly scattered wavelengths, permitting you to record the picture with only the less-scattered longer wavelengths. For maximum haze penetration, couple a deep red filter, such as the Wratten No. 29, plus a polarizer (discussed later in the chapter on colorless filters), with black-and-white infrared film. Note: This only works with true atmospheric haze. It doesn't work with thick fog or smog, which consist of relatively large water or pollutant particles that actually block visibility, rather than just scatter light waves.

Since black-and-white films, even panchromatic ones, are more sensitive to blue than our eyes are, what you get in black-and-white prints isn't quite what you see at the original scene. Blues photograph a bit lighter than you see them, and yellows photograph darker. If it is important to record a scene with a natural-appearing brightness relationship among the objects in the scene, use a yellow Wratten No. 8 filter when shooting in daylight, or a No. 11 yellow-green Wratten filter when shooting by tungsten (most indoor) light. These filters will correct the too-dark yellows and too-light blues.

For special effects, use your knowledge of how colored filters work with black-and-white film to create eerie scenes. A red filter will give fair-skinned subjects ghostly white complexions and lips, while turning blue eyes almost black. A blue filter can darken a blonde's

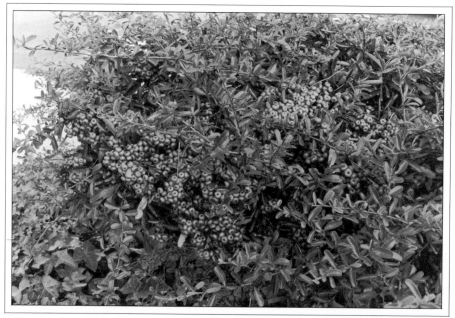

Since black-and-white film can't show the colors of subjects in a scene, subjects of different color but equal brightness — such as the red berries and green bush in this picture — will appear as the same gray tone in a black-and-white photograph.

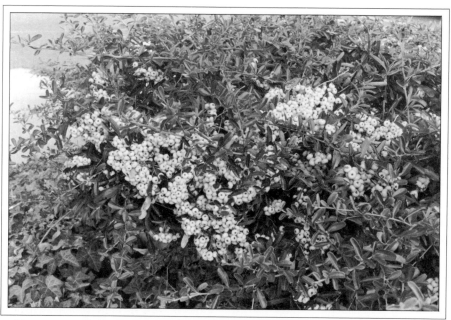

Putting a red No. 25 filter over the lens, and giving the film additional exposure to compensate for the light absorbed by the filter, results in light red berries against dark green foliage.

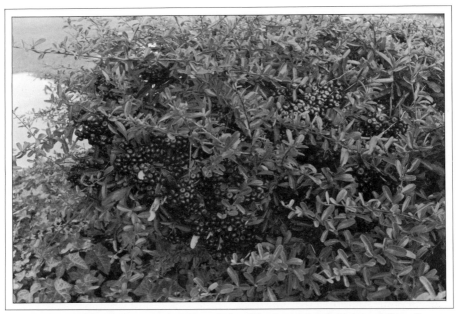

A green No. 61 filter has the opposite effect: dark red berries against light green foliage. A colored filter will lighten objects of its own or similar color, and darken objects of its complementary color in a black-and-white photograph. A prime use for colored filters in black-and-white is to create tonal differences between subjects of different color but similar brightness.

hair, lighten her blue eyes, and really emphasize any complexion blemishes — never use a blue filter to photograph anyone who doesn't have a fine sense of humor!

You can use a cyan (blue-green) filter to simulate the look of the orthochromatic black-and-white films that were used earlier in this century. These films were sensitive to blue and green light, but not to red, and so any objects in a scene that reflected a lot of red light, such as red lips, appeared very dark in the resulting photograph. Using a cyan filter, which absorbs the red wavelengths of light, will convert normal panchromatic (sensitive to all three primary colors of light — blue, green, and red) into simulated orthochromatic film.

Reference was made earlier to using colored filters properly. This means using a filter of the proper color, and exposing the film properly through it.

Selecting the proper color is simple: What do you want done to the scene? If you want to lighten a subject, use a filter of the subject's color. If you want to darken a subject, use a filter of the subject's complementary color. The only difficulty lies in trying to determine when two different-colored objects will photograph as the same shade of gray. But there's even a colored filter to help you do that! The Kodak Wratten No. 90 monochromatic viewing filter (catalog number 149 4871 in 50mm/2-inch square size; catalog number 149 6280 in 75mm/3-inch square size) is a deep amber gelatin filter that lets you see the approximate brightness relationships among the objects in a scene. You'll view the scene approximately as it will appear in a black-and-white photograph. Sandwich various colored filters (one at a time) with the No. 90 to see what effect each filter will have on the scene.

Determining how to expose film properly with the filter is a bit harder, but still easy. Each filter has an assigned filter factor, which tells you how much additional exposure you must give a scene when using the filter.

Why must you give additional exposure when using a colored filter? Because colored filters absorb some of the light coming through the lens. A colored filter transmits light of its own color, and absorbs light of other colors. That's how it changes the lightness or darkness of objects in a scene. A red filter absorbs green and blue light, so areas reflecting green or blue light, such as the sky, don't get as much light through to the film as they would if no filter were used. Therefore, they will appear lighter on the negative, and darker in the resulting print. Almost all the light from red objects reaches the film, since the red filter transmits red light, so red objects appear as they normally do in the print. But the red objects are supposed to be lighter, right? That's where the filter factor comes in. If you use the red filter and increase the exposure as per the filter factor, red objects will send more light than usual to the film, and so will appear darker on the negative and lighter on the print, while blue and green objects will still send less light than usual to the film (since most of the blue and green light is absorbed by the red filter), and so will appear lighter on the negative and darker on the print.

The accompanying filter-factor table will give you approximate filter factors for popular colored filters. If your filter isn't listed in the table, or if you'd like to figure out more precise factors, a simple test will tell you what you need to know. Take a meter reading from a Kodak Neutral Test Card (available at most photo stores in packs of four for very little money; the Kodak catalog number is 152 7795) and make an exposure of the card accordingly. Then attach the filter to the lens, and make another exposure with the same camera settings. Next, make another exposure, opening the lens half a stop. Continue making exposures in this manner, opening the lens another half stop each time, until you've given three or four stops more exposure than the meter reading called for with yellow and red filters, and five or six stops more exposure for deep green and blue filters. Once the film has been processed and dried, take the first frame — the one that was made at the metered exposure, with no filter on the lens — and find the filtered frame that matches it. The amount of additional exposure given that frame is the amount you should increase exposure each time you use that filter.

For most purposes, through-the-lens meters built into single-lens reflex cameras will adequately compensate for the presence of a colored filter over the lens, but for precise work, the scene should be metered without the filter, and the filter factor applied to determine the proper exposure.

COLOR PHOTOGRAPHY

One simple use of colored filters for special-effect color photographs is to enhance a color already in the scene. For example, you could use an orange or red filter to enhance a warm sunset, or to add color to a pale sunset. A green filter can turn a woodsy scene into an emerald empire. A blue filter will emphasize the cold feeling of a snowscape. Colors also can help convey emotions: red for anger or passion, green for jealousy, blue for sorrow. Think about how a strong color might affect your image, and if one will help, use a filter of that color. Delicate colors are possible too. You can use light-colored filters as well as more intensely colored ones, and it's often better to use a mild CC20 or CC30 color-compensating filter than a deep-colored filter to enhance an existing color.

Filter Factor Table

Filter Number	Color	Daylight		Tungsten	
		Factor	F-Stop Increase	Factor	F-Stop Increase
8	Yellow	2	1	1.5	2/3
11	Yellow-Green	4	2	4	2
12	Yellow	2	1	1.5	2/3
15	Yellow	2.5	1 1/3	1.5	2/3
23A	Red	6	2 2/3	3	1 2/3
25	Red	8	3	5	2 1/3
29	Red	16	4	8	3
47	Blue	6	2 2/3	12	3 2/3
47B	Blue	8	3	16	4
58	Green	6	2 2/3	6	2 2/3
61	Green	12	3 2/3	12	3 2/3

When you use colored filters with color film, it's best to bracket exposures. The "right" exposure will generally be somewhere between an uncorrected exposure and the one called for by the filter's factor (see the filter-factor table on this page). But you might prefer a lighter or darker rendition of the filtered scene, so bracket, keep notes, and you'll soon know how to expose many types of subject matter to get the effect you want.

One thing to bear in mind is how colored filters work. They transmit their own color, and absorb their complementary color. This goes for color photos, too. If you shoot a scene with a red filter, the filter won't turn the whole scene red. It will turn objects in the scene that reflect a lot of red wavelengths (reds, yellows, oranges, and whites) red; but objects that reflect little red (cyan, blue, and green) will appear very dark or even black. If you decide to turn a sunset green, remember that a green filter doesn't transmit many of the red and orange wavelengths of a typical sunset, so a very long exposure will be required.

One popular filter for giving a scene an overall color cast is the sepia filter offered in filter systems such as Cokin's.

Used with color film, the sepia filter produces warmish brown images that have that "old-fashioned" look. Especially effective with people subjects wearing period costumes, the sepia filter has an exposure factor of 2.5, but bracket exposures the first few times you use it (a good idea with any filter, actually).

Useful colored filters for special color effects (aside from the sepia) include color-compensating filters of .20 or .30 density in the desired colors. Kodak Wratten gelatin CC filters are available in the six primary colors — red, green, blue, magenta, yellow, and cyan — in densities from .025 to .50, and several other manufacturers also offer them. Also helpful are a red No. 25, a green No. 61, and a blue No. 38A (more about these in a bit) for stronger effects. An orange No. 85B and a blue No. 80A are handy to have. The No. 85B is ideal for warming up a scene or portrait; the No. 80A is great for cooling a scene and for moonlight effects (don't correct for the filter when exposing the film). These are also important in normal photography — the No. 85B lets you shoot tungsten-balanced color film in daylight, while the No. 80A lets you shoot daylight-

A blue filter not only lends an appropriate cold feeling to a misty waterscape, but actually increases the effect of the mist, since it transmits only the shorter blue wavelengths, which are scattered the most by particles in the air.

77

Fisheye and mirror lenses generally have a few colored filters built in, because acquiring filters large enough to cover the front of such optics would be a prohibitively expensive (and awkward) proposition.

Using a red filter over the lens to add color to an otherwise dull sunset is the natural thing to do, but for a more startling image, why not try a green filter for an emerald sunset? Hint: Since there are few green wavelengths in a sunset, you'll have to give a lot of exposure to get an image through the green filter—at least three stops more than when using the red filter.

balanced film in tungsten lighting.

Note: If you use colored filters for special effects with color negative film, let the processing lab know it, so the good folks there won't try to correct your efforts when they print the negatives.

Now, for a little colored-filter magic. If you put the camera on a tripod and make three exposures of a scene on one frame of daylight color film, one through a red No. 25 filter, one through a green No. 61 filter, and one through a blue No. 38A filter (remember them from a couple of paragraphs back?), an amazing thing will happen: anything in the scene that is not moving will appear in normal color, but anything that is moving will take on a rainbow of colors. This occurs because the "white" light for which color film is balanced actually consists of fairly equal portions of red, green, and blue wavelengths. Stationary subjects will receive equal exposure to the red, green, and blue wavelengths during the three exposures, and so will appear normal in the photograph. But moving subjects will be in one place on the film during the red-filter exposure, in another place on the film during the green-filter exposure, and in still another position on the film during the blue-filter exposure, thus appearing red, green, and blue; and where randomly moving subjects overlap on the film, magenta, cyan, and yellow.

If you use the three cited filters, determining exposure for this technique is simple. Take a meter reading in the usual manner, as though you were going to shoot without a filter. Open the lens one stop from the meter's recommendation, then make each of the three filtered exposures at that setting. You can use other red, green, and blue filters to produce this effect, but you'll have to do some experimenting to determine the proper exposure through each filter if you do, so it's best to try to get the three recommended filters. They should be

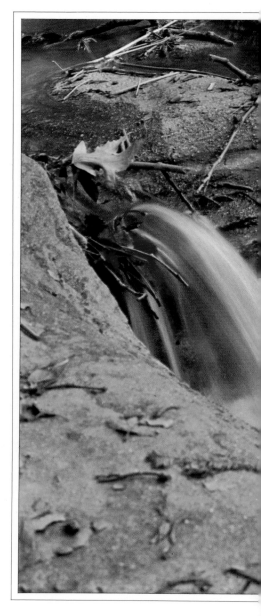

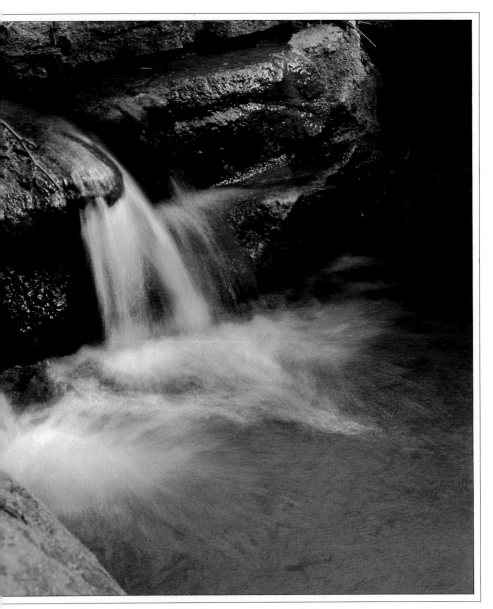

The three-filter technique — making three exposures on a single
frame of film, one through a red filter, one through a green filter,
and the third through a blue filter — creates magical images
in which stationary objects appear normal, but anything moving
in the scene takes on rainbow colors. These three exposures were
made on a frame of Ektachrome 64 Professional
film in a Mamiya RB67 camera, using No. 25 red, No. 61 green,
and No. 38A blue filters. Each exposure was made with the
lens opened one stop from the meter's recommendation
for a single, unfiltered shot.

81

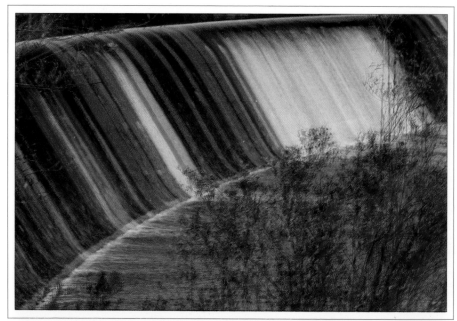

While trying the three-filter technique with a camera that (I learned later) couldn't make in-register multiple exposures, I produced this off-register image. The film moved slightly between the red-filter exposure and the blue and green exposures. The result doesn't look like much — until you view it through a pair of 3-D glasses (the kind with one red lens and one blue-green lens). Then, it appears to be three-dimensional. If your camera won't make in-register multiple exposures, you can make 3-D images by exposing through the red filter (open up one stop from the no-filter exposure); then use the double-exposure technique described in the chapter on exposure to cock the shutter and make another exposure on the same frame through a sandwich of the green and blue filters (open up two stops from the no-filter exposure). Note: You can build a Harris shutter to use the three-filter technique.

available at most large photo stores. Kodak catalog numbers for 75mm/3-inch square gelatin filters are: red No. 25, 149 5605; green No. 61, 149 5894; blue No. 38A, 149 5720.

If your camera won't make in-register multiple exposures, you can make a cardboard slide that holds the three filters end-to-end, and drop it in front of the lens, with the shutter open on B, so that the three filters pass in front of the lens in sequence. A cardboard box that attaches to the lens and guides and catches the slide completes the unit. This device is called the Harris shutter, after Robert Harris, who invented it. Full directions on its construction and use can

be found in Kodak publication No. KW–13, *Using Filters*. Naturally, since this device makes the three exposures rapidly one after another, it works best with fast-moving subjects like flames, breakers, and athletes. The three-separate-exposure technique (with cameras that will make in-register multiple exposures) allows you to let time elapse between the exposures, so you can use it for slower-moving subjects like clouds.

There are several split-color filters on the market. These are half one color and half another, or half one color and half clear. As you'd expect, they permit you to turn one half of your scene one color and the other another. You could use a

A Harris shutter and a large fan combined to produce this interesting portrait of model Denise. The camera's shutter was opened on B, and the Harris shutter's slide (containing the red, green, and blue filters) was dropped into its box in front of the lens to expose the film; then the camera shutter was closed. The blowing hair ends took on color, while the skin of the motionless model retains its natural coloring.

half-orange, half-clear filter to add color to a weak sunset sky, while leaving the foreground in natural colors. You could use a half-red, half-blue filter to enhance both a sunset sky and the blue ocean beneath it. As is the case with most special effects, imagination is the key ingredient with these filters.

Most split-color filters are graduated; that is, the density of the color is greatest at the edge and tapers off toward the middle of the filter, rather than having a consistent density that suddenly ends in the middle of the filter. This helps blend the area of the picture where the two halves of the filter meet, as does shooting with the lens aperture wide open. For a sharper separation, stop the lens down.

If you have square (rather than circular) colored filters, you can make your own split-color filters, by attaching two

These images were all produced with the same filter (except the top left, which was made with no filter to show what the scene actually looked like). The filter? A red/blue color polarizer. Rotating this filter changes both the color and the degree of polarization, yielding a variety of effects. Note: When using a color polarizer, bracket exposures, beginning with two stops more than called for by an in-camera meter reading through the filter.

colored filters to the lens, each covering the portion of the scene you wish to be that color. You could use just one colored filter, covering half the lens, to produce your own half-color, half-clear filter. Filters from a system, such as Cokin's, work best for this, because their system filter holders were designed to permit one filter to be inserted from the top and another from the bottom. The two slide together until they meet (in the middle or closer to top or bottom, as desired), and the whole assembly is rotated to any desired orientation. If you have gelatin filters, you can tape them together, or even cut them to fit over a plain glass circular filter, then attach to the lens.

Another type of color special-effect filter is the dichroic polarizer, which combines color with polarization. Some of these filters come with the polarizer built in, while others require use of a separate polarizing filter. There are two basic varieties: the single-color type, which changes in density and saturation as you rotate it (such as from weak pink to deep red); and the two-color type, which contains two colors, and so changes color as well as saturation and density when rotated (a red-blue one would change from deep blue to pale blue to magenta to pale pink to deep red, for example). Combine these features with the polarizing effects, and you can produce some unusual color images obtainable no other way.

Color spot filters have a clear circular area in the center, surrounded by a colored diffused area. These filters produce a clear central area in the image, surrounded by a soft, colored area. The surrounding diffusion emphasizes the subject in the clear center area, while the surrounding color (if appropriately chosen) enhances the colors of the rest of the image. As with most image-altering filters, the effect is subtle at large lens openings and more pronounced at smaller apertures.

7
Colorless Filter Effects

QUITE A FEW COLORLESS SPECIAL-EFFECT filters are available at your local camera store. These produce a variety of effects, such as stars, fog, diffusion, vignettes, multiple images, and even some spectacular color effects.

STAR FILTERS

Star filters turn point-light sources into stars in your photographs. Several varieties are available, to produce 4-, 6-, 8-, 12-, and 16-point stars. The star effect is produced by the filter's crisscross line pattern (the better-quality star filters contain lines engraved in glass, but even embossed plastic star filters will produce the effect). These line-pattern grids come in 1mm, 2mm, 3mm, and 4mm versions, the numbers indicating the millimeter spacing between the lines in the pattern. The closer the line spacing, the brighter the stars produced, the longer the rays, and the more diffused the overall image. Conversely, the wider grids create less intense stars with shorter rays, and little softening of the overall image. The larger grids require brighter point-light sources to produce stars, while the finer grids will produce stars from dimmer sources. Generally, the best star effects are produced at intermediate lens apertures, because at small apertures the effect diminishes, and at larger apertures the diffusing effect is too strong for crisp images, which are generally the most effective type of star images.

A variant on the star-filter theme is the variable star filter, which consists of two elements, each containing a pattern of parallel lines. By rotating these elements relative to one another, you can control the angle of the stars' rays.

You can make your own star filter by simply positioning a piece of window screen in front of the lens. Coarse-mesh screen produces effects similar to those of the wider-spaced star filter grids, while finer-mesh screens yield effects like those of the finer-grid star filters. Most commercially produced star filters require no exposure change, but window screens probably will — white screen material reflects a lot of light, diffusing the image and reducing exposure, while black screen material will block a lot of light, reducing exposure. If you make your own star filters, bracket a few test exposures to see just how much compensation is required.

FOG FILTERS

As you'd expect, fog filters make the scene look foggy. The best ones do this in much the same way as the airborne water particles of real fog: by scattering the light, thus producing lowered contrast, muted colors, halos around lights, and an overall softness of the image. Double fog filters produce less flare than regular fog filters, and make closer subjects appear sharper then distant ones, for an even more realistic effect.

Fog filters don't require any exposure compensation per se, because they have little effect on image density, but overexposure does tend to increase the foggy effect, while underexposure tends to reduce it. Additionally, shooting with the lens wide open increases the effect, while stopping the lens down decreases it. Since fog filters come in several strengths, you can, through choice of strength, exposure, and aperture, produce a wide variety of fog effects, although for most photographers, one medium-strength fog filter will suffice.

While night scenes at a pier are probably the most obvious candidates for fog-filter shots, forest scenes (especially when strongly backlit), meadows, and even pretty models also make good subjects.

DIFFUSION FILTERS

Like fog filters, diffusion filters soften the image, but they do this — in theory, at least — without reducing contrast. Some diffusion filters just make the image unsharp, but the good ones spread highlights into shadow areas and soften the image without graying the image or greatly reducing definition. There is a difference between a "soft" image and an "unsharp" one — a soft, diffused image has a dreamy, airy look, and you can still "count the eyelashes" in a soft portrait; an unsharp image just looks out of focus, and you cannot pick out each individual eyelash in an unsharp, fuzzy portrait.

Diffusion filters lend a dreamy, glamorous effect to portraits (while at the same time masking wrinkles and skin blemishes), and a light, airy effect to scenics.

Some manufacturers offer only one diffusion filter, while others offer several strengths. Tiffen, for example, offers diffusion filters in five strengths, plus several Sofnet filters, which also produce a diffused effect. The Sofnet filters consist of net material laminated between glass, and come in white, which adds a misty look and causes halation effects in highlights; black, which gives a soft look without halation or grayed blacks; red, which adds warmth as well as diffusion to color shots; and skin tone, which diffuses and enhances skin tones. In addition, each color is available in four strengths. Stronger diffusion filters generally work better in harsh, contrasty lighting; they produce too great an effect in softer illumination, but you might like that. One moderate-strength diffusion

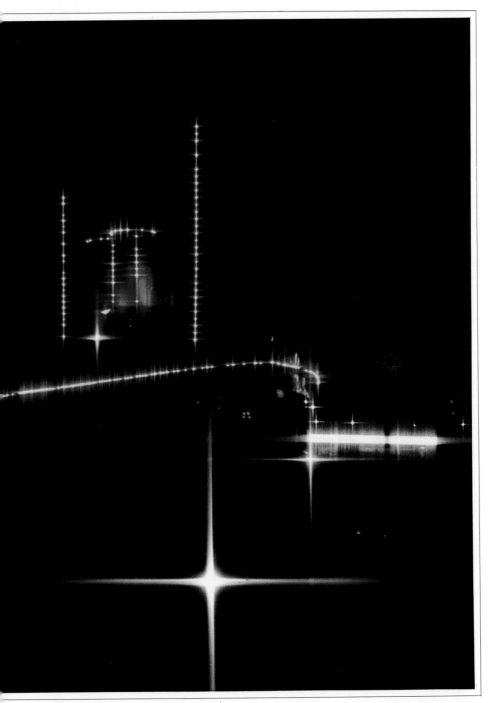

Star filters turn bright lights in the scene into stars. The filters can be rotated to orient the star points as desired.

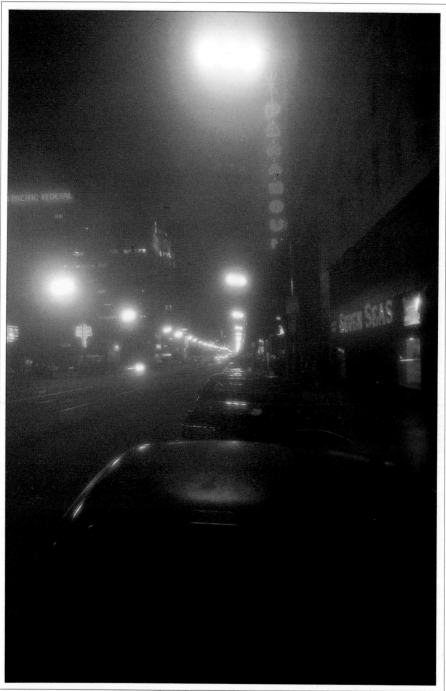

Fog filters make the scene appear foggy — they soften and reduce sharpness and contrast, and produce diffuse halos around lights.

filter will suit most photographers well, but if you shoot a lot of glamour-type portraits, or are really serious about diffusion, you'll probably end up buying a whole set of diffusion filters.

You can alter the degree of diffusion with a single filter by varying exposure (more exposure generally emphasizes the effect, within limits), film development (more development equals more contrast; less development equals less contrast), and lens aperture (the diffusion is greatest at wide apertures, and with some types of diffusion filters, it may even completely disappear at the smaller apertures).

One handy special diffusion filter is the Arkay PicTrol, a large plastic body containing a 40mm central hole with semiclear plastic teeth that open and close in a diaphragmlike manner. A ring around the circumference of the body controls the position of the teeth. Since the teeth can be positioned anywhere from wide open (no diffusion) to completely closed (so much diffusion you can't tell what the subject is), this is a versatile tool for the diffusion-minded photographer on a tight budget. The PicTrol is one of those diffusion filters whose effect is greatly dependent on lens aperture, so once you've set the PicTrol to an amount of diffusion that looks right in the viewfinder, stop the lens down to shooting aperture with the depth-of-field preview to see what happens. You might have to dial in more diffusion or open the lens to produce the desired effect.

The PicTrol was designed to fit on an enlarger to diffuse images while printing, so it must be adapted to fit on a still camera. The best way to do this is to epoxy an adapter ring that will screw into the front of your camera lens onto the back of the PicTrol. Due to the small 40mm opening, vignetting will occur with lenses shorter than about 100mm on 35mm cameras, but most diffusion subjects (portraits) are best photographed with lenses in the 100–135mm range anyway.

When an image is diffused by a filter on the camera lens, the effect is different from that produced by using a diffusion filter under the enlarger lens to diffuse a normal image. Diffusion filters spread bright areas into dark ones, so when the filter is used over the camera lens, the highlight areas spread into the shadows. But when printing a negative, tones are reversed: the filter will spread the bright (on the negative) shadow areas into the dark (on the negative) highlights — an unnatural effect with most diffusion subjects.

You can make your own diffusion filters. Swirling some petroleum jelly onto a UV filter can produce some beautiful diffused effects, and you can customtailor them to your subjects by watching the scene through the camera's viewfinder while applying the jelly. Apply it with a coarse brush such as a toothbrush to flare the highlights strongly. If you spread the jelly around the edges of the filter, you'll get a softly vignetted effect, with a sharp image in the center blurring outward. A little experimentation here will provide you with many fascinating effects. Be sure to remove the petroleum jelly before storing the UV filter.

You can also make your own net diffusers from fine-mesh nylon stocking material. Just stretch the material over the lens and hold it in place with a rubber band. White stocking material will produce more flare; black will maintain black shadow areas. Colored material will add its cast to color images, while neutral material will retain accurate color rendition — you can produce whatever effect you want.

Another homemade diffusion filter consists of a cross made of thin (1/8-inch or so) strips of clear cellophane tape, which is fastened over the front of the lens. Tape the ends to the lens barrel;

Diffusion filters all soften the image, but the degree and manner of softening varies from manufacturer to manufacturer. This sequence of model Diane (who was patient enough to sit through six diffusion filters) shows some of the varied effects available. The Minolta S2 filter (bottom left) produces a pleasant, typical diffused effect. The Cokin Diffuser 1A (top left) has an effect somewhat more subtle than the Minolta filter. The Arkay PicTrol produces a variety of effects, depending on the filter setting

and the lens aperture; the shot on the top
right uses an intermediate setting at the same
aperture (f/5.6) used for all of these shots. A
standard eight-point star filter produces a
slight diffusion effect (top left). A piece of
nylon mesh with a few holes punched in it
produces strong softening (top right). Two thin
strips of transparent cellophane tape at right
angles to one another over the lens produce a
lot of flare and corresponding reduction in
contrast (lower right).

This multiple-image shot was made with the Cokin A 201 filter, which consists of four facets surrounding a central hole.

don't let the sticky tape touch the glass. This "filter" can actually produce beautiful results, strange as it may seem.

VIGNETTERS

Vignetters are colorless lens attachments that have a clear central area surrounded by some form of diffusing material — a diffusion filter, translucent plastic, or even plus-diopter glass. Regardless of type, they all do essentially the same thing: produce a sharp central image that diffuses toward the edges.

When used at large lens apertures, vignetters produce images that are somewhat diffused all over; when used at small apertures, they produce relatively sharp central images surrounded

Vignetters emphasize the central subject, and are useful for eliminating distracting backgrounds.

MULTIPLE-IMAGE FILTERS

As you'd expect from their name, multiple-image filters produce multiple images of your subject on the film. There are several varieties. One has a clear center section surrounded by several glass segments (usually four, five, or six), and produces a relatively sharp central image surrounded by a number of less-sharp peripheral images. Another type has three or six triangular facets, and produces three or six images — none of which is completely sharp, since there is no clear area to transmit a direct image — in a triangular pattern. A third type is half clear glass, with the other half consisting of several segments; this produces a sharp image with several less-sharp secondary images to one side. There are other variations, including filters with each segment a different color so that each image is a different color (tape pieces of colored transparent material to the segments of a colorless multi-image filter for the same effect).

You must consider several things when using multiple-image filters. First is the effect of lens focal length. Long lenses will produce a large main image, with secondary images partially or wholly out of the frame, while wide-angle lens can cause vignetting, and thus the disappearance of some of the outer secondary images. Normal lenses generally produce the best results.

A second consideration is aperture. Shooting with the lens stopped down produces the sharpest images, but may actually include an out-of-focus image of the filter facets in the picture. Shooting with the lens wide open produces a soft overall effect, so intermediate apertures are generally best.

A third consideration is distance: moving farther from the subject causes

by a vague, unsharp light area. The transition between sharp and unsharp areas is more gradual at wider apertures, and more sudden at smaller ones. No exposure compensation is required. A good vignetting filter can take the place of a diffusion filter for most uses, because the effects produced by both filters are similar at wide apertures.

Diffraction gratings break up white light into its spectral components, causing rainbow slashes to emanate from light sources in the picture.

the peripheral images to spread out and possibly to move clear out of the picture, while moving closer causes the secondary images to move closer together. All of these effects can be seen in the viewfinder of a single-lens reflex camera; use the depth-of-field preview to check the effects of different apertures.

Although multiple-image filters are generally most effective with large, bold subjects against plain backgrounds, sometimes busy subjects can make effective shots, especially in color. If the multiple-image idea intrigues you, get a multiple-image filter and experiment with it; you'll soon learn how to produce results that suit your aesthetic taste.

DIFFRACTION GRATINGS

Diffraction gratings contain thousands of parallel lines that break up light from point-light sources in a scene into the colors of the spectrum. They come in two forms. Transmission diffraction gratings transmit as well as diffract light, and so can be used over the camera lens to turn point-light sources into spectral slashes of color in photographs. Reflection diffraction gratings don't transmit light, and so cannot be used over the lens, but they can be used to reflect the spectral colors onto subjects for special effects. No exposure compensation is necessary when using diffraction gratings, and you can see in the viewfinder the effect you'll get. The filter can be rotated to change the direction of the spectral slashes.

LASER FILTERS

Laser filters are basically holographic (laser-produced) diffraction gratings that contain families of parallel lines produced by interference patterns of laser

Laser filters create patterns of rainbow slashes around light sources — they're just fancy diffraction gratings. Patterns of circles, stars, and slashes are available from several manufacturers.

light, rather than just the single series of parallel lines found in standard diffraction gratings. These patterns produce more spectacular and varied spectral patterns: stars, swirls, and zigzags of color, and often multiple images.

While standard diffraction gratings transmit most of the light unaltered, laser filters affect somewhat more of the light coming through them, and so do not produce sharp images as standard diffraction gratings do. Standard diffraction gratings are more subtle, retaining subject form and detail while adding touches of spectral color; laser filters produce spectacular color effects that can overpower the image. As is the case with diffraction gratings, laser filters require no exposure compensation, although the effect will vary with exposure. Bracketing is a good idea, at least when you first start to use a laser filter.

Any scene that contains point-light sources or specular highlights is a good subject for laser filters, as well as for conventional diffraction gratings.

NEUTRAL DENSITY FILTERS

Neutral density filters cut down the amount of light without doing anything else to it. They come in handy for special effects requiring slow shutter speeds, when the light is too bright to use those speeds otherwise, and for those requiring a wide-open aperture in bright light.

Kodak Wratten neutral density filters come in strengths from .10 to 4.00, each .10 cutting the light by one-third stop (a .60 ND filter reduces the light by two stops, for example). Other manufacturers designate their neutral density filters as 2×, 4×, etc., indicating the amount the exposure must be increased when using the filter (increase exposure four

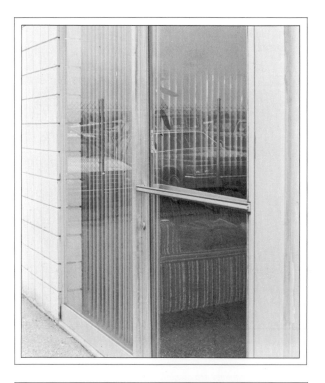

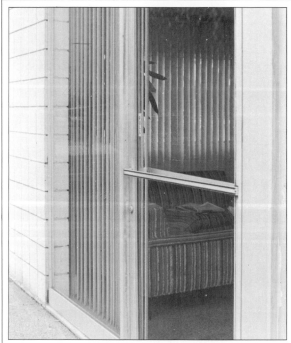

Polarizing filters can eliminate reflections from nonmetallic objects. If you see a reflection (top) and don't want to, just attach a polarizer to the lens and rotate the filter until the reflection is gone (bottom), then shoot. Remember to increase exposure 2.5× (1⅓ stops) when using a polarizer.

times, or two stops, when using a 4× filter.

A special type of neutral density filter is the graduated one. This filter is half neutral density (various strengths are available) and half clear glass. It is useful for such things as shooting a scene with a very bright sky and a very dark foreground. Rotate the filter on the camera lens so that the neutral density area covers the sky area, and you can make a photo with detail in both bright sky and dark foreground. You have to decide how much you want to reduce the sky's brightness. (Meter the foreground, then meter the sky, and see how much brighter the sky is. Then choose a graduated ND filter of the required strength to balance the sky and foreground exposures, or one that will produce the desired density in the sky when the exposure is made for the foreground.) As you gain experience shooting such scenes, you'll learn how much to reduce the sky's brightness to produce the image you want.

POLARIZERS

Polarizing filters polarize light; that is, they transmit light that is vibrating in only one direction. Normal (nonpolarized) light waves vibrate in all directions perpendicular to their direction of travel. When light passes through a polarizing filter, the vibrations in only one direction are transmitted. This property of polarizing filters makes them quite useful for several other things.

When light strikes a nonmetallic object, the vibrations in only one direction are reflected. Therefore, by rotating the polarizing filter so that it does not transmit light vibrating in that direction or plane, you can eliminate these polarized reflections. If you see reflections in your scene and don't want to see them in your photograph, attach a polarizer to the lens, rotate the filter until you don't see the reflections, then shoot. Note: Reflections from metallic surfaces are already

polarized, so a polarizer cannot eliminate them.

Since much light from the sky is polarized when it is reflected by dust and water particles in the air, the polarizing filter can be used to eliminate these reflections and thereby darken the sky in a photograph. This is the best way to darken a blue sky in a color photo—if you try to use a yellow or red filter to do it, as in black-and-white work, the whole scene would take on a yellow or red cast. Just attach the polarizer to the lens, and rotate it until the sky is as dark as you want it. Maximum sky darkening will occur when the sun is to your right or left; little darkening will occur when you shoot directly toward or away from the sun. (Graduated neutral density filters will darken a blue sky in color photographs, but they will also darken any objects that extend into the sky portion of the scene, such as the tops of trees.)

Another nice effect the polarizer produces is more intense colors in color shots, because it eliminates the polarized glare and reflections that desaturate colors.

The polarizer has a filter factor of 2.5 (open the lens 1⅓ stops); this applies at all times, no matter how the filter is rotated. It's best to take a meter reading without the polarizer on the lens, because the polarizer can cause erroneous readings with some through-the-lens metering systems. Once you've made the reading, open the lens 1⅓ stops, attach the polarizer, and shoot. (Tiffen makes circular polarizers that do produce correct readings with beam-splitting metering systems, if you have a camera such as the Canon F-1 or the Leicaflex, which employ such systems.)

One thing to keep in mind when using a polarizer is that you don't have to rotate the polarizer to its maximum effect for all photographs. Sometimes partial polarization will produce a more effective image. Additionally, you can use the

polarizer as a $2.5 \times$ (.40) neutral density filter by setting it for minimum effect.

CRYSTALS

You can use two polarizing filters to produce some spectacular effects when photographing crystals. Put one polarizer on the camera lens, and the other between your light source and the crystals. Rotate the filter on the lens until you see an effect you like, and shoot. You'll need some sort of close-up gear to allow you to focus close enough to the crystals to get a reasonable image size — a true macro lens, extension tubes, or bellows units work well.

To make the crystals, place a small amount of the chosen chemical on a sheet of glass (a glass microscope slide works well), crush it gently, and cover with another slide glass. Slowly (and carefully) heat the chemical until it spreads out between the two slide glasses, then let it cool. Alternatively, you can dissolve a small amount of the chemical in a couple of drops of water, and let it evaporate on a single slide glass (this takes longer). Good chemicals to use are Epsom salts (hydrated magnesium sulfate), citric acid, dextrose, photographic fixer (sodium thiosulfate), and photographic developer. A scientific supply company can provide these and other suitable chemicals.

When photographing your crystals as described above, it's wise to stop the lens down to maximize depth of field. Stopping the lens down, combined with the light reduction of your close-up device (macro lens, extension tube, etc.), will result in long exposure times, so you should mount the camera on a tripod, use a cable release, and (if the camera has one) use the mirror lock-up to reduce vibrations during exposure. Bracket exposures until you gain some experience with the technique, and whenever you are in doubt as to the correct exposure.

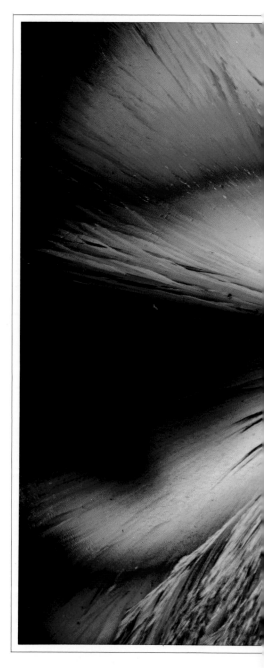

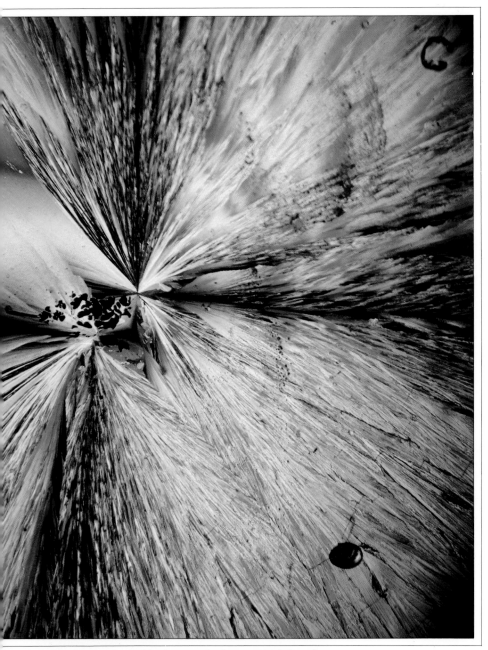

Jim Zuckerman made this photograph of urea crystals by using
two polarizing filters: one positioned in front of the camera lens,
and the other between the light source and the backlit crystals.
Jim used two lenses to produce the needed magnification:
a short telephoto attached front-element-to-front-element to
the telephoto with a double-male-thread adapter.

8
Close-Up Lenses

CLOSE-UP LENSES ARE CLEAR, FILTERLIKE lens attachments that enable you to focus your camera lenses on much nearer subjects than is normally possible. These plus-diopter disks (similar to eyeglass lenses used to correct farsightedness) come in numbered strengths from +1 through +10 diopters, although strengths greater than +4 are not widely available. A few companies offer +1/2 close-up lenses, which are half the strength of the +1, and the weakest practical close-up lens.

A +1 close-up lens will focus the camera lens at one meter when the camera lens is focused at infinity — setting the camera lens's focusing ring to a closer setting will set focus of the combination slightly closer. A +2 close-up lens will set focus at one-half meter, a +3 close-up lens at one-third meter, and so on. The +1/2 close-up lens sets overall focus at two meters. These overall focus distances apply regardless of the focal length of the camera lens to which the close-up lens is attached.

You can combine close-up lenses to produce more strength: a +2 and a +3 close-up lens together equal a +5 (setting overall focus at one-fifth meter), for example. When using two close-up lenses at one time, attach the higher-numbered one to the camera lens first, then attach the lower-numbered close-up lens to the higher-numbered one.

Using close-up lenses is simple. Just attach one to your camera lens, move the appropriate distance from your subject (one meter for a +1 close-up lens, one-half meter for a +2, etc.), and inspect the image in the viewfinder. If you like what you see, shoot; if you want to get closer, for more magnification, use a stronger close-up lens. Note: You'll find it easiest to move the whole camera back or forward slightly to focus, rather than trying to focus with the camera lens's focusing ring.

Close-up lenses offer the advantage of being simple to use and relatively inexpensive, but they also have a couple of drawbacks. First, they cause a loss of image sharpness, especially at the edges. This loss is greater with the stronger close-up lenses. Second, while close-up lenses give you more image magnification than is possible with the camera lens alone, they won't get you quite to life-size. If you want really high magnification (life-size and greater), extension tubes or bellows units are necessary. Any good book about close-up photography will explain these devices.

For special-effects work, close-up lenses can be used to produce abstract images of small portions of everyday objects, and the extremely limited depth of field at such close focusing distances can be used to great advantage in selective-focus shots (see the chapter on focus effects).

SPLIT-FIELD LENSES

Split-field lenses are essentially close-up lenses cut in half. The diopter portion of the split-field lens lets you focus on a very near subject, while the plain portion of the filter keeps background objects sharp as well. If the split-field lens is used carefully, images showing incredible depth of field can be made. The trick is to position the filter's dividing line properly, in an area of the image where it won't show. Split-field lenses can be rotated to position the dividing line at any desired angle.

A strong (+ 4) close-up lens will let you focus a 200mm camera lens less than a foot away, for enough magnification to abstract portions of TV images. Note: When photographing images on the TV screen, use a shutter speed of 1/8 second or slower with leaf-shutter cameras; otherwise you'll get horizontal or diagonal bands across the image in the photograph — although these bands themselves can be an effective special effect.

In black-and-white, close-up textures make good subjects for close-up lenses.

Close-up lenses let you see and photograph the world up close, by decreasing the minimum focusing distance of your lenses. Everyday objects take on a new fascination from up close. Jim Zuckerman recorded this flower image using a close-up lens.

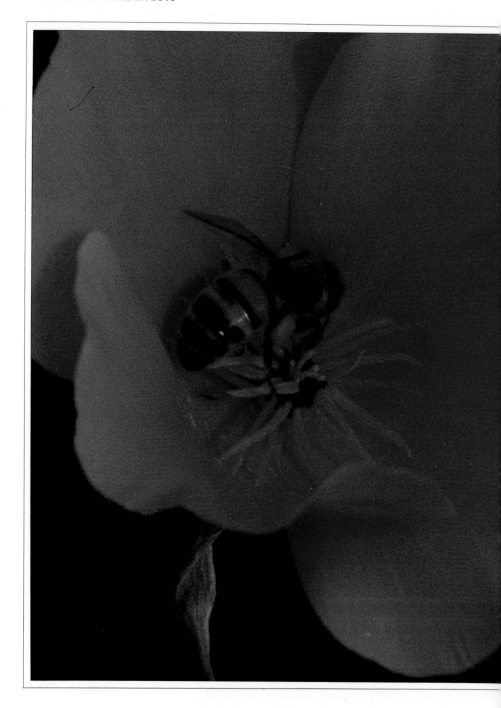

Selective focus and rich colors can make for stunning close-up shots. At such close lens-to-subject distances, the depth of field is very limited, making selective focus almost essential, even when using small lens apertures.

Split-field lenses are half close-up lens and half clear. They let you focus on a very near subject (through the close-up lens half) and a very far one (through the clear half) at the same time.

With split-field filters, you can shoot a golf ball on a tee very near the camera and very large in the frame, and still have the golfers and golf course in the background sharp. Or you can shoot a small can of soup close-up on the left, and show a distant person on the right, with both in sharp focus, making it appear that the soup can is bigger than the person. Split-field lenses are another tool at your imagination's disposal.

It's generally best to focus on your far subject first, then position the near subject so that it is in focus within the diopter half of the lens. If you can't move your subjects, focus on the far one, then move the camera closer to or further from the near subject until it is sharp; because the far subject is so distant, the few inches of fore or aft movement necessary to bring the near subject into focus shouldn't have a noticeable effect on the far subject's sharpness. You should stop the lens down as far as possible, though, to maximize the depth of field. It's helpful to attach your camera to a tripod to maintain your composition solidly once it's established.

Even at f/22, my telephoto lens was not able to hold both the lamppost at the left and the distant scene at the right in focus at the same time (top). Attaching a +1 split-field lens to the telephoto lens, and rotating the split-field lens so that the close-up lens portion covered the left side of the frame, enabled me to hold the whole image in focus (bottom).

9
Matte Boxes and Masks

MATTE BOXES AND MASKS LET YOU PUT ONE subject in several places in the same photograph, vignette a subject in various shapes, and put the shaped vignetted subject into another environment.

The simplest such device is the half-mask, such as Cokin's double-exposure filter B 346. This is simply a filter that is half clear and half opaque. It fits in front of the lens, blocking out half of the image frame. Make one exposure of the subject on the left side of the frame, with the mask blocking the right side; then make a second exposure, moving the subject to the right and reversing the mask so that it blocks the already-exposed left half of the frame. Naturally, the camera must be attached to a tripod to maintain the composition during the two exposures.

You can make your own masks by cutting a half-circle of opaque material to fit over a UV filter, or by cutting third- or quarter-circles to put your subject in three or four places in the scene.

Since the exposures do not overlap, no exposure compensation is necessary; shoot each at the camera settings you'd use to make a single exposure of the whole scene. (One exception might occur if one of the portions of the scene is in deep shadow, and you'd like to increase the exposure of that portion to provide better detail. Two cautions if you try this. First, increase the exposure by adjusting the shutter speed; make all of the exposures at the same lens aperture, or the images won't blend naturally. Second, you're liable to get an unnatural-looking scene if you lighten one shadow area and not the others. Consider these points, and the option is yours.) With wide-angle lenses, keep the lens aperture at f/8 or larger; with longer lenses, you can stop down further.

Matte boxes are bellows-type lens shades that contain a slot into which you can insert various effect cards. One set of cards consists of different masks, which are used the same way as the simple masks just described. You can use the masks to cover up portions of the scene while exposing other portions, thus positioning a single subject in several places throughout the picture.

A second set of cards for the matte box comprises a series of positive and negative mask pairs. For example, one pair might consist of an opaque star shape on a clear background, and its complement, a clear star shape cut out of an opaque background. A number of shapes are available to suit your imagination, and you can cut your own shapes as well. With the star pair, you could make an exposure of the "star" tennis player in your family using the card with the clear star and opaque background; then make a background exposure of a tennis match using the card with the opaque star and the clear background. The resulting photograph will show your star in a star, surrounded by the tennis match. Again, give each scene normal exposure, because the two images do not overlap. Large lens apertures will produce a somewhat gradual blending of the central and background images, while small apertures will sharply delineate the shape of the mask.

Vignetting cards for the matte box produce a central image of the subject in a shape, as the positive/negative masks do, but instead of providing a new background, vignetting cards just surround the central image with black. Choose the

The matte box, combined with this card, will let you put one subject in four places in one scene. The card is placed to expose the top left portion of the scene as shown here; then the bottom left, bottom right, and top right portion are exposed. You can make the four exposures in any order, but all must be on the same frame of film. Since the images do not overlap, normal exposure should be given to each.

desired shape, set the aperture for the desired transition effect between subject and surrounding area, and expose as usual. Aside from producing unusual images, vignetting matte-box cards are useful in eliminating distracting backgrounds from the image.

Some matte boxes offer shaped aperture cards. These turn out-of-focus highlights into bright spots in the shape of the opening in the card. Stars, suns, hearts, and pinwheels are some of the ready-made aperture cards available; you can always cut your own to suit a specific idea you want to try. These effects are strongest with lenses of about twice the focal length of the camera's normal lens. Set the camera lens to its maximum aperture to throw the highlights really out of focus. Nearby subjects with backgrounds that contain lots

of specular highlights, such as a sparkling ocean, are very effective with this technique. For studio work, you can punch some holes in a dark sheet of poster board, and set this up behind your model as a background. Light the poster board from behind, and you'll have a whole field of bright highlights that turn into shapes with the aperture cards.

THE COKIN LINEAR SHUTTER

The Cokin linear shutter set B 354 consists of two pieces of black plastic, one containing a very narrow slit, and the other containing a wider slit. Each piece fits into the Cokin filter holder, just like any other Cokin filter.

If you attach one of these slit plastic pieces to a short telephoto lens (100mm or so for a 35mm camera), and focus on a nearby subject, the nearby subject

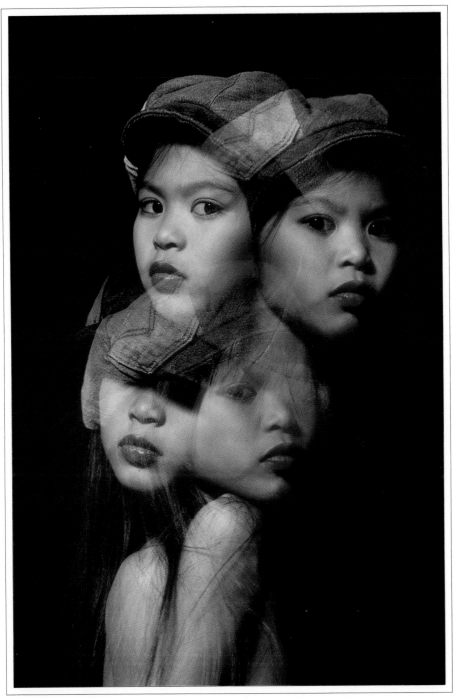

Jim Zuckerman used the matte box and card shown in the photo at left to make this composite shot of model Bee Ontrakarn.

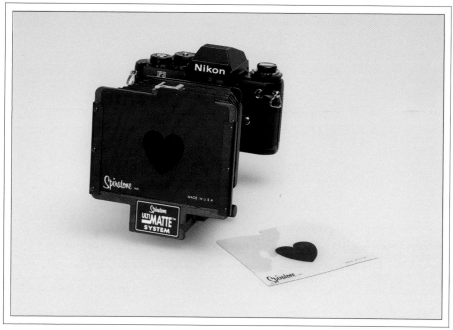

A positive/negative mask, consisting of an opaque card with a shape cut out of it, and a clear card with a corresponding opaque shape, can be used to create two interesting types of pictures: vignettes and composites.

will appear sharp in the photo, while the background will appear blurred, as though the camera had been panned across it. Thus, the subject seems to be moving rapidly, when in fact it is not moving at all. Keep the lens aperture wide open when using this technique, since stopping it down negates the blurred effect on the background, and adjust the shutter speed to control exposure. The narrow-slit shutter requires about seven stops more exposure than a normal shot of the scene would, and the wider-slit shutter requires about five stops of additional exposure.

These linear shutters will produce another fascinating effect with wide-angle lenses. With the lens cap in place, run a whole roll of film through the camera without exposing it (set the lens to its smallest aperture and the shutter to its fastest setting for this). Remove the lens cap, compose an image with the wide-angle lens, attach the camera to a tripod to maintain the composition, set the camera shutter to B, attach one of the linear shutters to the lens, and you're ready to make some amazing images.

Now all you need is a subject to move through your frame. As it does, open the camera shutter and rewind the film as smoothly as possible. The resulting image will show a compressed, elongated, or wavy subject, depending upon the subject's rate and direction of motion, the rate at which you rewind the film, and whether you keep the camera still or pan it. Exposure depends on how rapidly you rewind the film. You'll have to do some experimenting with the linear shutters to zero in on exposure and effect, but start your testing with the camera set at f/8 in bright sunlight with medium-speed film.

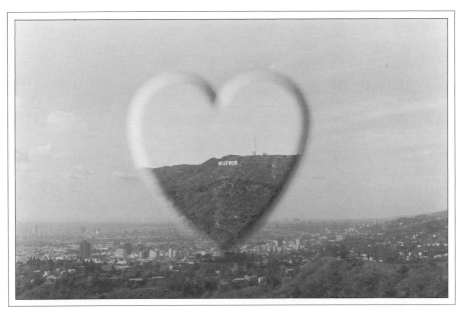

If you produce a vignette as in this picture, then use the corresponding mask to block out the exposed central area of the frame, you can expose another scene to surround your subject with an image instead of black. Here, the Hollywood sign was photographed using the same opaque card with heart-shaped cutout used for the photo of Debbie; then this mask was removed, the clear mask with the opaque heart in its center was positioned in the matte box, and a second exposure (this one of Hollywood itself) was made on the same frame.

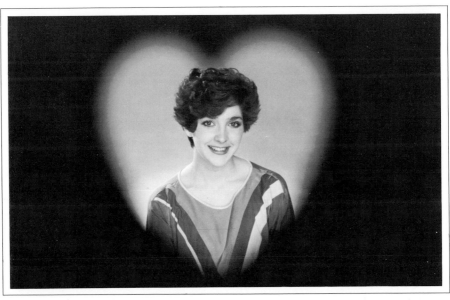

Photographing the subject through the opening in an opaque mask card produces a vignette. Model Debbie was photographed through a mask with a heart-shaped opening.

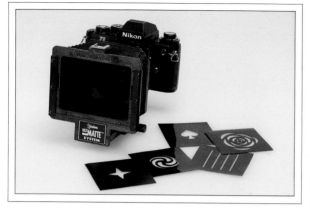

Shaped-aperture cards fit in the back of the matte box, and turn out-of-focus highlights into the shape of the cutout in the card.

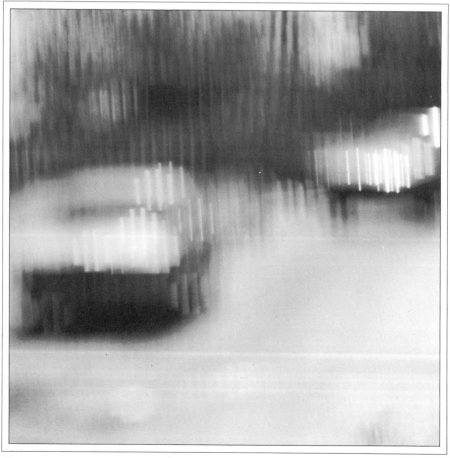

Here are some effects that can be produced by inserting various shaped-aperture cards into the matte box and throwing the scene out of focus. The card containing four slits produces some particularly interesting effects (top).

Cokin's linear shutter consists of two pieces of opaque plastic, one with a very narrow slit, and one with a wider slit.

If you attach a linear shutter to a short telephoto and focus on a nearby subject, the background will appear blurred, as if panned, even though both subject and camera remain still.

Another linear-shutter effect is produced by advancing the film to the end of the roll with the lens cap in place, so you don't expose it, and then opening the camera shutter on B and smoothly winding the film back into the cassette, using the rewind crank. Depending on the nature and movement of the subject, and the rate at which you rewind the film, you'll get a variety of effects. Photo by Jim Zuckerman.

10
Lens Effects

SEVERAL SPECIAL TYPES OF LENSES LEND themselves well to special-effects work, because each produces an effect obtainable in no other way. These special-effect lenses include zooms, fisheyes, soft-focus lenses, mirror lenses, and anamorphic lenses.

ZOOM LENSES

Zoom lenses produce a unique explosion effect if they are zoomed during the exposure. There are several variations on this technique, each producing a somewhat different result.

The basic explosion effect is produced by setting the camera shutter for an exposure of 1/30 second or longer, attaching the camera to a tripod (you can hand-hold the camera if sharpness is not important), setting the zoom lens at its shortest focal length, and centering the subject in the viewfinder. Press the shutter button, then zoom the lens to its longest focal length. The result will be a shot in which the central subject emits "zoom rays" to the edges of the frame. You can experiment with different shutter speeds (being sure to zoom the lens through its entire focal-length range during the exposure for maximum effect), but speeds between 1/30 and 1/2 second generally work best.

One variation on this technique is to start the shot with the zoom lens set at its longest focal length, then zoom to its shortest focal length during the exposure. The effect thus produced is generally not as satisfactory as zooming the lens the other way, because the result is an imploding rather than exploding image, but try a few shots anyway — you might like the results.

If you use longer exposures (at least 1/2 second), you can leave the lens set at the initial focal length for some fraction of the exposure (say, half), then zoom to the final setting. This will yield a more identifiable central subject, while still producing the zoom effect. Be sure to use the correct aperture for the shutter speed you select — sometimes neutral density filters are handy to permit you to use longer exposure times.

Another way to retain subject detail while also producing zoom rays is to put the subject in the shade and illuminate it with an electronic flash unit during the zoom. The flash will freeze a relatively sharp image of the subject on the film, while the zooming creates rays in the background. Be sure to balance the flash with the background lighting. If the exposure for the background is 1/30 second at f/8, make sure the flash is at a distance from the subject that calls for f/8. If you use tungsten-balanced film, and a No. 85 conversion filter over the flash head, you'll get a normal-color subject with a bluish background (see the chapter on flash effects for more details about this technique).

Another variation is to make several exposures on the film frame, each with the zoom lens set at a different focal length. A variation on this variation is to give one or more of the exposures more exposure than the others, to emphasize one or more of the zoomed images. You won't get zoom rays with this technique, since the lens must be zoomed during the exposure for that, but you'll get a series of concentric but different-sized images of your subject in the picture.

The best subjects for zoom effects are those with backgrounds that contain light and dark areas, although zooming

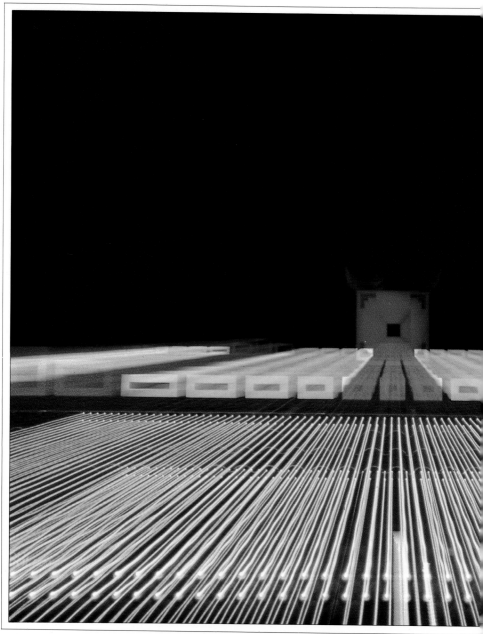

Changing the focal length of a zoom lens from the shortest to the longest during a 1/2-second exposure is a versatile special-effect technique. Attach the camera to a tripod, center the main subject in the frame, press the shutter release, and zoom the lens. It will take you a few exposures to get the timing down, so that the full zoom ends just as the shutter closes, but even your mistimed results will be unusual.

a light-and-dark subject against a plain background can also be effective. If you experiment with different shutter speeds, rates of zooming, and subjects, you'll soon have a selection of effective special-effect images for your efforts.

FISHEYE LENSES

Fisheye lenses cover an extremely wide 180-degree angle of view, and curve any straight lines that don't go right through the middle of the frame. There are two types of fisheyes: circular, which produce a circular image with a 180-degree angle of view in all directions; and full-frame, which "crop" a rectangle out of the 180-degree circle, filling the frame, but covering 180 degrees only diagonally.

Naturally, round subjects are good ones for circular fisheye lenses. So are architecture, a partly cloudy sky with the camera pointed straight up, and whatever else your imagination can dream up. Full-frame fisheyes produce unusual effects with many subjects, but the effects are more subtle, because the image covers the whole frame. Whenever you see a circular fisheye shot, you know immediately something is unusual, because the image is round; with full-frame fisheyes, it's the curving of lines at the edges of the frame, and the curving of the horizon line if the camera is pointed up or down at all, that provide the unusual effect.

Circular fisheye lenses are very expensive, but fisheye adapters are available at much lower cost. These attach to the front of a normal lens, increasing the angle of view and producing circular images. These images aren't quite as sharp as those produced by true fisheye lenses, but the basic effect is the same, at a fraction of the cost.

SOFT-FOCUS LENSES

As their name implies, soft-focus lenses produce soft images, but not totally unsharp ones. One type employs aperture

125

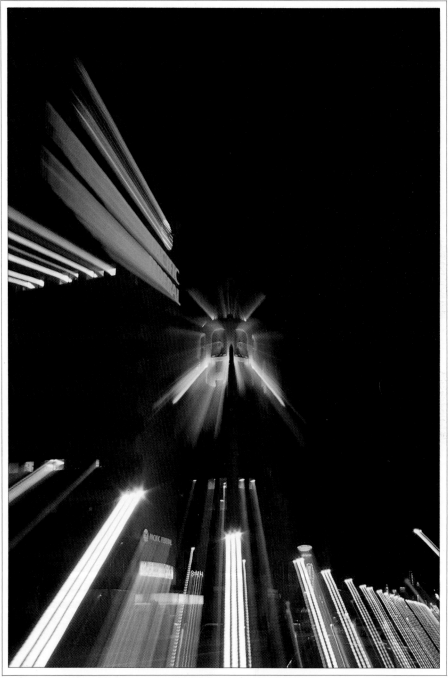

If you pause for a moment after opening the shutter before zooming, you'll get an identifiable subject as well as zoom streaks. This shot was begun at the lens's longest focal length (105mm), then zoomed to the shortest length (35mm). The exposure time was one second.

disks that are inserted into the lens body. These contain a large central hole surrounded by smaller holes. The large central hole produces a normal, sharp image on the film; the smaller holes form additional images on the film, slightly off-register with the main central image. Since these additional images are formed by smaller apertures, they are not nearly as intense as the sharp main image. The net result is a softly glowing image in which the highlight areas are spread gently, but the darker areas (such as eyelashes in portraits) remain relatively unaffected. Such lenses must be used with the lens aperture set to the value of the disk or a larger aperture: if you're using an f/5.6 disk, you should not stop the lens down past f/5.6.

The second type of soft-focus lens is simply not corrected for all aberrations, so it produces a sharp image within a soft one on the film. With this type of lens (the Sima SF soft-focus lens is an inexpensive example), maximum softening is produced at wide apertures; stopping the lens down sharpens the image. The Sima lens comes with two aperture disks (an f/4 and an f/5.6) to reduce the amount of softening and control the light transmitted by the lens, since the lens itself has no aperture settings, and is a permanent f/2.8.

Soft-focus lenses work best with high-key subjects, and are very effective for glamour-type portraits. But they're also effective with nature, scenic, and still-life portraits. When combined with a sepia filter, a soft-focus lens can produce a very authentic-looking "old-time" photograph, one that resembles an old-fashioned daguerreotype.

You should bracket exposures when working with soft-focus lenses, at least until you've gained some experience with them and some feel for the effect, because sometimes a half stop of exposure can make the difference between a great soft-focus shot and a so-so one.

MIRROR LENSES

Aside from their long focal lengths, which apparently compress distances and produce huge sun balls in sunset shots (to get a really huge sun ball, focus the lens at its closest focusing distance, or on a nearby subject with the sunset as a background), mirror lenses turn out-of-focus highlights into doughnut-shaped highlights. They do this automatically; it's a side effect of the design of the mirror lens. All you have to do to take advantage of it is find a suitable subject with background highlights that will be thrown out of focus when you zero in on your subject, such as a silhouetted figure against a sparkling sea, and shoot.

ANAMORPHIC LENSES

Anamorphic lenses squeeze and expand images. They see a lot of use on motion-picture cameras and projectors. On the camera, they squeeze a wide scene so it fits onto the film; then, on the projector, they expand the squeezed film image to fill the wide movie screen.

For still-camera special effects, anamorphic lenses can squeeze your subject into a tall, thin form, or expand it into a short, wide form, or even stretch it diagonally into a really weird form — all by merely rotating the front portion of the anamorphic lens.

Since the anamorphic lens is primarily a movie-industry tool, you'll have to check with motion-picture suppliers, or hope to find a used one at a photo dealer. No manufacturer currently makes one ready to use with still cameras.

To use the anamorphic lens, attach it to the front of the normal camera lens. Some form of adapter ring is generally needed for this, since anamorphic lenses are threaded for movie-camera and projector use, rather than still-camera use. The camera lens's aperture ring is used to control the light transmitted to the

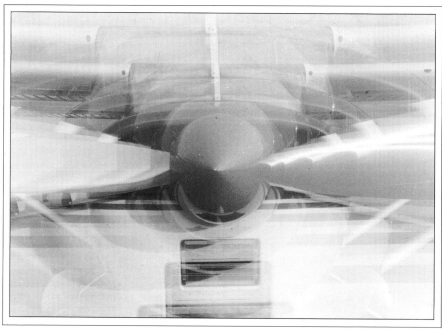

Another interesting zoom-effect variation, for symmetrical subjects, is to make several exposures on one frame of film, each at a different focal length. If you want each image to have equal strength, multiply your film's ASA/ISO speed by the number of exposures, and make each exposure as per the meter reading so obtained. If you want one image to predominate, give it more exposure than the others. This subject is the front of a Cessna 182 airplane. Four exposures were made with a 35-50mm, 85mm, and 105mm settings. The film's ASA speed was multiplied by four (the number of exposures), and the meter's ASA index set to this speed to determine the settings for each exposure.

The fisheye lens's 180-degree view of the world makes it ideal for straight-up shots of the overhead hemisphere. Since the image produced by a fisheye is round, the lens covers 180 degrees in all directions — horizontally, vertically, and diagonally. Fisheye lenses curve subjects at the edges of the frame, and that goes for full-frame fisheyes, which crop a rectangle out of the circular fisheye image to fill the frame, as in this shot, as well as for circular-image fisheyes.

film (it's best to stop down at least to an intermediate aperture for best image quality), and the camera lens's focusing ring is used to focus. With a single-lens reflex camera, you can see the effect produced as you rotate the anamorphic lens. When you see an effect you like, use the camera's through-the-lens meter to determine the correct exposure, and shoot.

The simple and inexpensive Sima SF soft-focus lens can really soften an image, as it does here with a shot of model Allison.

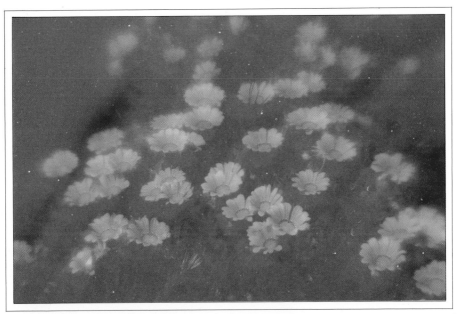

People aren't the only suitable subjects for the soft-focus treatment. Here, a green filter and color infrared film combine with the Sima lens to produce a dreamy field of flowers.

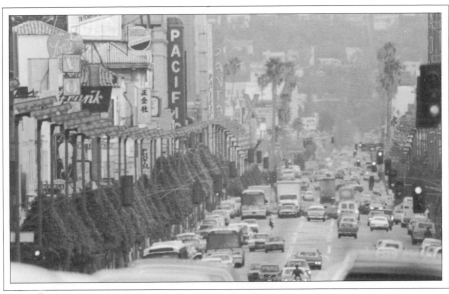

Mirror lenses, due to their long focal lengths, zero in on a small portion of a scene, compressing it. The compression is due to the great distance between camera and subject—the big "X" is ten blocks away from the 1000mm lens used to make this shot. If you could blow up the center section of a shot of the same scene made with a normal 50mm lens, to cover this same small area of the scene, the perspective would be the same (although the 50mm image would be extremely grainy and fuzzy, due to the extreme degree of enlargement).

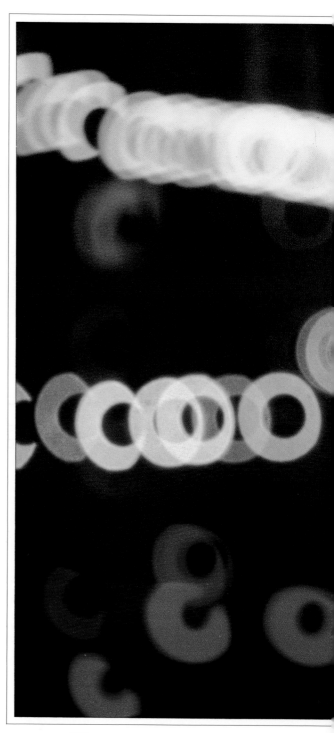

Mirror lenses turn out-of-focus highlights into "doughnuts." For this image, a night street scene was thrown out of focus with a 500mm mirror lens.

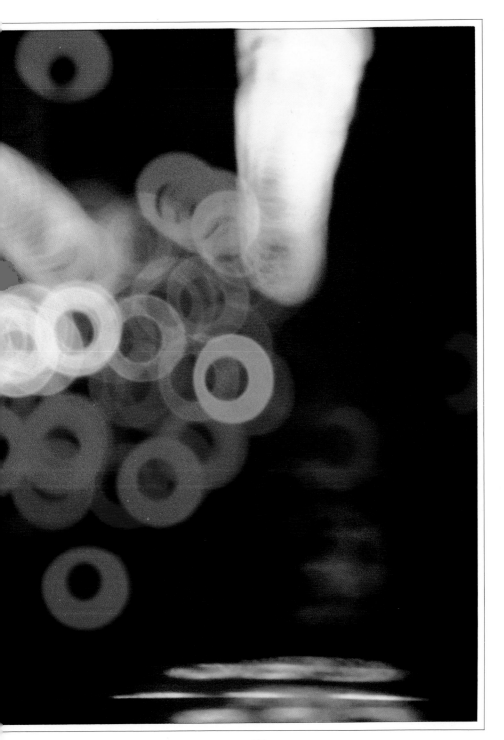

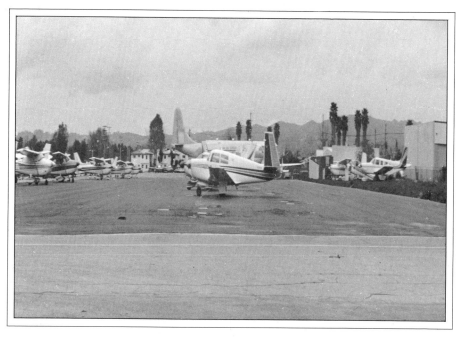

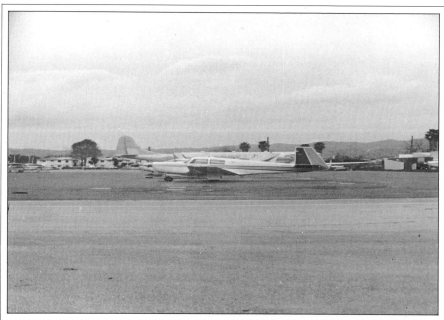

Anamorphic lenses can be rotated to compress (top left), elongate (bottom left), and diagonally stretch (top right) a subject (the normal scene is at bottom right). You'll have to stop the camera lens down to f/11 or further in order to produce a sharp image when using an attached anamorphic

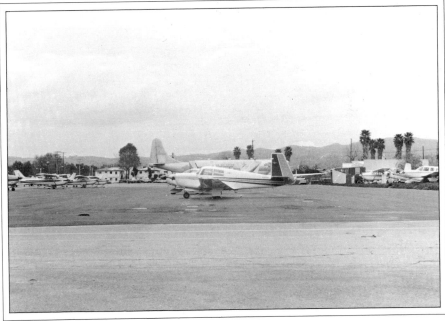

lens; at such small apertures, vignetting may occur. Use the depth-of-field preview to check for vignetting and overall sharpness. Move further away from the subject so that it occupies only the center portion of the frame if vignetting does occur, then crop out the vignetting when you make a print.

11

Slide Copier Effects

SLIDE COPIERS CAN DO A LOT MORE THAN just duplicate your existing slides. You can improve defective slides, sandwich a colored filter with an existing slide image to add color, sandwich a texture screen or other texture source to add dimension, sandwich two existing images to produce a new one, and more.

SLIDE COPIERS

Slide copiers can be as simple as tubes that attach to the end of the camera lens (or even directly to the camera) and make same-size copies. There are also very expensive slide-copying machines that combine the camera with a bellows unit and lens to provide almost any desired degree of magnification. They place the slide on a special-effects compound that rotates the slide precisely to any desired angle for multiple-image effects, and horizontally or vertically for any desired cropping. These machines contain their own light source. The Bowens Illumitran has a built-in electronic flash; the Sickles ChromaPro utilizes a tungsten light source — be sure to use color film balanced for the light source if you want correct color balance in your copies. Simple slide copiers can be pointed at the sun or an electronic flash unit (use daylight-balanced color film), or at a slide projector or tungsten lamp (use tungsten-balanced film). If you use electronic flash as the light source with a simple copier, you'll have to shoot a bracketed test series to determine the correct exposure; with continuous light sources, the camera's built-in meter will put you in the general range, although bracketing is still a good idea. See the manufacturer's instructions for exposure starting points with the copy machines.

The expensive machines almost require a book of their own to describe all the things they can do, which is why they are used primarily by professional multi-media slide show producers. If you can get access to one of these marvels, by all means do it. But remember that you can do a lot with even the simplest copiers.

IMPROVING SLIDES

If you have a slide that is too light or too dark, you can (within limits, of course) correct this when making a copy by altering the exposure. Increasing the exposure of the copy will result in a lighter-than-the-original copy; decreasing exposure will produce a darker-than-the-original image. If the color balance isn't quite right on an original slide, use an appropriately colored filter to correct it. If the original is too yellow, for example, sandwiching a blue filter with it will correct the yellow cast. But which blue filter? Sandwich blue color compensating filters of different densities with the slide and view the combinations on a light box — whichever filter makes the slide's color look right to you is the one to use.

ADDING COLOR

Colored filters can do almost anything to an existing slide image that you could do to the original scene with the same filter. If you want to photograph a sunset, and it's not colorful enough, you can attach a red or orange filter to the camera lens, and add the missing hues. Likewise, if you have a slide shot when there wasn't enough color in the sunset, sandwich that same red or orange filter with the slide in the slide copier to add the missing hues. It's that simple to add colors to your slides.

OTHER FILTER EFFECTS

Color filters aren't the only special-effect filters that work well with slide copiers. Diffusion and fog filters can be used as well, provided they are attached to the camera lens so that the light travels through the slide being copied before traveling through the filter. Star and laser diffraction filters can be used with slides that contain specular highlights, although the effect will not be as great as it would have been if the filter had been used over the lens when making the original shot. Multiple-image prism filters don't work well with simple slide copiers, but can be used, attached to the camera lens, with copying machines.

TEXTURE

Commercially available 35mm texture screens can be sandwiched with the subject slide in the slide copier to add texture to the copy image. Alternatively, you can use texture-producing materials of your own, such as lens-cleaning tissue. You'll have to bracket exposures when using these screens, because the camera's through-the-lens meter can easily be fooled by them. Actually, it's a good idea to bracket exposures any time you're using the slide copier; if you do that and keep notes as to what you did, you'll soon be able to zero in on the right exposure with all kinds of subjects.

SANDWICHES

By sandwiching another slide with a subject slide, you can create all kinds of unusual new images. Take your subject slide and some other slides you think will work well with that image, and superimpose them on a light box, trying out various combinations and relative positionings. When you find something that works, mount the two slides together in a single slide mount, insert in the slide copier, and shoot.

A little common sense applied while choosing the images to put together will

The simplest slide-copier special effect is sandwiching a colored filter with an original image to add color to the original. Here, a red filter was sandwiched with a color slide of a freeway made with a mirror lens; the sandwich was copied using a simple slide copier.

An equally simple technique is adding texture to an image by sandwiching the image slide with a texture slide (here, photographer Jim Zuckerman used a slide of canvas texture), then copying the sandwich with the slide copier.

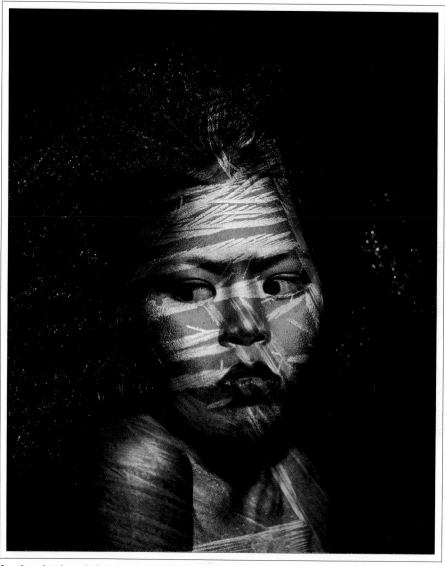

Another simple technique is to sandwich two slide images together. Jim Zuckerman sandwiched a portrait of model Bee Ontrakarn with a double-polarized crystal image (see the polarizer section of the chapter on colorless filters), then copied the sandwich with a slide copier.

keep you out of trouble. Don't sandwich two dark slides together, because the two images will block each other out. You can see problems of this sort on the light box, so they're easy to avoid.

You can even sandwich more than two images, if they are all fairly light, but you'll get the best results by using only two images. It's a good idea to stop the lens down as far as possible even with two slides, because depth of field at a 1:1 reproduction ratio is extremely limited.

To make a bas-relief image, sandwich a color original slightly out of register with a negative copy of the original. Here, Jim Zuckerman sandwiched a toned positive with a high-contrast Kodalith negative, and used the slide copier to copy the sandwich. To obtain a negative copy of your original, use the slide copier, and load the camera with Kodak Kodalith or Technical Pan 2415 film. Note: If the slide copier's degree of magnification is adjustable, set it for 1:1 (same-size) reproduction.

If your slide copier permits cropping, or you use one of the expensive copying machines and have a bellows unit on the camera, you have more flexibility in making two slide images merge — you can crop the second image precisely as needed to fit well with the first. Make an exposure with the first slide in the copier. Then remove the first slide, insert the second, and adjust the magnification and positioning so that the second image fits into the first as you desire. Make a

second exposure of this slide on the same frame of film. For an even balance between the two images, give each half the exposure you'd give if you were copying a single image; by giving one image more exposure than the other, you can emphasize the more-exposed image.

Besides sandwiching two ordinary images, you can create very effective results by sandwiching a colorful slide, such as a sunset, with a silhouetted subject shot against a light background, thus producing a final image with the silhouette against the colorful sunset.

MORE MULTIPLE EXPOSURES

If your slide copier permits different magnifications, you can make several shots of one image on the same frame of film, increasing (or decreasing) the magnification each time, to produce a slide-copier zoom effect.

Another multiple-exposure variation is to use a single slide, but move it between exposures. One example of this is to make the first exposure with the subject just to the left of center in the frame; then make a series of lesser exposures with the subject positioned progressively to the right. This technique can lend a motion effect to an appropriate image.

USING DIFFERENT FILMS

You can copy an original slide with color negative film, then sandwich the resulting negative image with the original, slightly off register, to produce a bas-relief effect. If you don't want to deal with the orange mask built into color negative films, copy your original onto an E-6 process color-slide film, and process the slide film in C-41 color negative chemistry (or have a friend or color lab do it for you). The result will be a negative image without a colored mask. Sandwich this with the orginal. You can also copy the original onto black-and-white film, and sandwich the resulting

black-and-white negative with the original for a different effect.

Another interesting variation is to copy an original slide onto Kodak Ektachrome Infrared film, with no filter. Then copy the original again, using normal Ektachrome 64 film, and process this in C-41 color negative chemistry to obtain a maskless color negative. Sandwich this negative in register with the infrared copy, and copy the sandwich. The result will resemble a color posterization, made in-camera.

Quite a number of unique images can be produced from one original slide by using different films to copy it with, and sandwiching different combinations of the resulting images, both in and out of register.

Here's Jim Zuckerman's original shot of a tapestry tiger.

Jim copied the original slide onto Ektachrome Infrared film to produce this image.

Copying the original onto regular Ektachrome, then processing the slide film in color negative (C-41) chemistry, gave Jim this image.

Zuckerman then sandwiched the photos on pages 141 and 142 to produce this in-camera color posterization.

12
Flash Effects

MANY FASCINATING SPECIAL EFFECTS CAN BE produced with electronic flash units. Among them are unusual color images, sharply frozen images of fast-breaking action, multiple images, ghost images, and creative lighting effects.

COLOR EFFECTS

If you have one flash unit and three different colored filters, you can make three exposures of a subject on one frame of film, each with a different filter over the flashtube, and each with the flash at a different position relative to the subject. The result will be a subject bathed in light of three different colors (or more, if the light from the flash exposures overlaps).

You can produce the same effect with cameras that won't make in-register multiple exposures by using three separate flash units, each covered by a different colored filter. One flash can be connected to the camera's hot-shoe, another to the camera's PC socket, and the third fired by an inexpensive slave unit.

Three is an arbitrary figure here; you can use two or four or more units (or flashes from one unit), depending on the image you want and the equipment at your disposal.

Another effective technique is to set up your subject so that the light from the flash unit illuminates only the subject, and none of the rest of the scene; then put a colored filter over the flashtube. The resulting photograph will show a normal-colored background and a filter-colored subject.

Naturally, you'll have to shoot some test exposures to determine how much additional exposure to give the shot to compensate for the light absorbed by the filter over the flashtube. The colored filter's black-and-white filter factor (see the table on page 75 in the chapter on colored filters) will give you a good starting point. For example, if you're using a red filter that cuts the light by two stops, use that as a starting point, and bracket a series of test exposures from there. Some flash manufacturers offer special-effects filter kits for their flash units; these kits include instructions that tell you how much to increase the exposure when using each filter.

Cokin's Color Back filters produce yet another unique effect. These come in pairs of complementary-colored filters, one to fit on the camera lens and the other to fit over the flashtube. The filter on the camera lens turns the whole scene its color; the complementary filter on the flash eliminates this cast from a subject lit by the flash.

To use the Color Back filters, place one on the camera lens, and take a meter reading (with the camera set on manual if you have an auto-exposure camera) of the scene through the filter. Set the camera shutter and lens aperture according to this reading. Then put the complementary filter on the flash unit, and position the flash unit at a distance from the subject that requires one stop less exposure than the aperture set on the lens. For example, if the camera's meter reading calls for an exposure of 1/60 second at f/11, put the flash unit at a distance that calls for f/16. This way, you'll be giving one stop more exposure than the flash-to-subject distance calls for; this added exposure will compensate for the filters.

FROZEN ACTION

Most manual camera-mount electronic flash units (and automatic units, when used on manual setting) have a flash duration of around 1/1000-second. This in itself is brief enough to "freeze" many moving subjects on your film; it's the same as using a shutter speed of 1/1000 second on the camera for nonflash shots. Actually, it's better — with most cameras, particularly mechanical-shutter models, the marked 1/1000-second setting yields a slightly longer shutter speed, perhaps as long as 1/750 second.

If you want to stop an even faster-moving action, an automatic flash unit can do it for you if you move it close to the subject. At their farthest operating distances, auto units produce their longest flash duration (1/1000 second usually). When you move the unit closer to the subject, the flash provides correct exposure by reducing the flash duration. It has to, because the aperture remains constant throughout the operating range, so exposure time — the flash duration — is the only thing it can change to reduce exposure at closer flash-to-subject distances. At the unit's closest operating distance (usually two or three feet from the subject — it varies from unit to unit), the flash duration is generally in the area of 1/20,000 second — brief enough to freeze almost any activity.

Naturally, since the very brief auto flash durations occur at very close operating distances, you'll have to choose subjects that permit using the flash unit very close to them. Large subjects are out, because the flash unit's angle of coverage is not wide enough to cover a large subject in its entirety at such close range. You can get around this limitation to some degree if you have a flash unit with variable power settings. Set the unit to its lowest power setting, and you'll get its briefest flash duration from

Soft bounce illumination is a special effect that retains the crisp, clean character of electronic flash while yielding much more flattering portrait lighting than the harsh rays of direct flash. This studio portrait of model Debbie was lit by two flash units. The main light, to the right of the camera, was enclosed by a Larson Soff Box, which is a large, square device that encases the flash unit. The light must pass through the box's translucent covering to reach the subject, and in so doing is diffused or softened. The fill light was bounced off a Larson Reflectasol Hex, a hexagonal, umbrella-shaped reflector. Bouncing the light off a reflector onto the subject also softens it.

One simple but spectacular flash special effect can be achieved by using two or more flash units to light the subject, each with a different colored filter over its flashtube. To produce this striking shot of model Bee Ontrakarn, Jim Zuckerman put a blue filter over the flash unit in front of her, and a red filter over the back-light flash unit. If you don't have a flash meter to determine exposure, bracket a series of exposures when using this effect, to make sure you get one shot that properly compensates for the filters' light absorption.

Automatic flash units, when used close to the subject, have very short (up to 1/20,000 second) durations, short enough to freeze many actions. A small automatic flash unit was positioned just out of frame to the left for this shot of a hammer smashing a light bulb. Caution: Take care when doing such things—I threw a similar bulb and watched it burst at a safe distance to see how big the explosion would be, but still cut my hand a bit making this shot. Wear gloves and protective goggles if you try this.

any distance. However, at such low power settings, the flash unit will probably have to be used very close to the subject in order to provide sufficient exposure. If you have several such flash units, you can set them all to their lowest power, position them so that their combined beams cover the whole subject, and use slave units to fire the additional flash units.

An additional consideration is getting the flash to fire at the right moment. With many subjects, precise timing is necessary, or the exposure will be made too early or too late to catch the action. For example, if you want to freeze the moment a hammer hits a lightbulb, you'll need some way to ensure that the flash fires at just that moment. The best way to do this is by means of a sound trigger,

Getting a bit trickier, Debbie was positioned for a close-up portrait on the right, then farther away for a medium shot on the left. Again, this type of shot can be done in the dark with the shutter open on B (as described in the text), or by using a black felt background and a camera with multiple-exposure capability (which is how this shot was made).

Model Debbie rehearsed moving from one position to the other as I watched in the viewfinder to set up this shot. The room was then darkened, the camera shutter was opened on B, and the flash was fired (using the open-flash button) to make the first exposure. Then Debbie moved to the second position, and the flash was fired a second time to produce the twin image. The shutter was then closed. If your camera will make double exposures, you can do this with the lights on, using a black felt background. Position the first image, make the exposure, cock the shutter without advancing the film, position the second image, and make the second exposure.

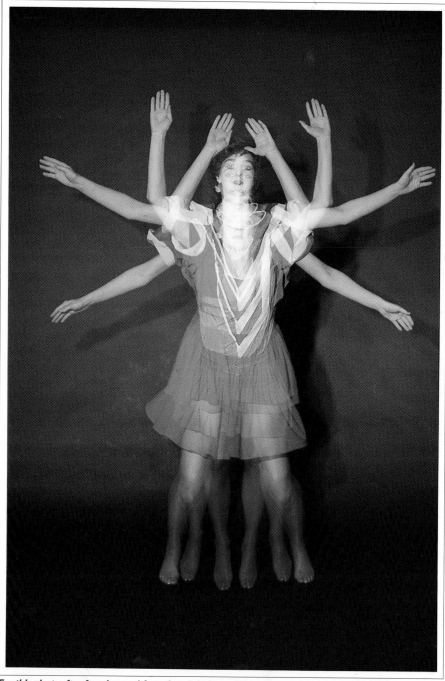

For this shot, after framing and focusing, I darkened the room and turned on the Wein
Cronoscope as Debbie did jumping jacks. Firing at an intermediate rate, the Cronoscope froze
several images of Debbie's motion during the one-second exposure.

such as the Wein WP-ST unit. This device fires the flash when a sound occurs. Set up the shot in a room that can be darkened, then darken the room, open the camera shutter on B, and break the bulb. The sound of the hammer hitting the bulb will cause the sound trigger to fire the flash. Close the shutter, turn on the lights, and you've got your image. Any action that produces a sound can be recorded in this way. You will, of course, want to make sure that no extraneous sounds occur that might trigger the flash prematurely.

For frozen-action subjects that don't make a sound, you'll have to either construct some sort of electric-eye triggering device, or just shoot a lot of exposures, trying to anticipate the action.

MULTIPLE IMAGES

There are several ways to make multiple exposures with electronic flash units. One is to darken a room, open the camera shutter on B, fire the flash unit using its open-flash button, move your subject to a new position, fire the flash again, and repeat as many times as desired.

Attach the camera to a tripod, and, with the lights on, plan out the positions for the subject. If your subject is a person, have him or her practice moving from one position to another, while you watch through the viewfinder, directing the subject to compose the multiple image. Once you have the positioning down pat and the focus set, you're ready to darken the room and shoot. Before turning out the lights, make sure the scene is clear of obstacles that might trip up your subject (or yourself, if you're going to move an inanimate subject from position to position during the shot).

A variation on this technique is putting a filter over the flash or camera lens for one of the exposures. Be sure to open the lens aperture to compensate for the filter's light absorption. You'll have

to do it by feel, counting the click stops, since you'll be doing it in the dark. Another variation is having the subject move closer for one of the exposures. You'll have to rehearse precise subject positioning and practice changing focus in the dark to accommodate the new position. You can somewhat simplify this type of shot by having the subject sit in a chair located at the lens's minimum focusing distance for one of the exposures; then you can begin the shot with the subject at the farther position, and have him or her move into the chair while you turn the focusing ring all the way to its minimum focusing distance stop for the next exposure.

Determine exposure for these multiple images in the usual manner: use the flash unit's guide number to determine the proper aperture for each exposure. If your images will overlap, take this into consideration. Multiply the film speed by the number of overlapping exposures, and use the guide number for this figure to determine the aperture(s) to be used. For example, if you'll be making three overlapping exposures, and you're using ASA 32 film, multiplying 32 by 3 exposures gives you a film speed of 96 (100, for all practical purposes). Use the flash unit's guide number for ASA 100 film (or set the flash unit for ASA 100) to determine the aperture for each exposure, based on the flash-to-subject distance(s).

It's a good idea to make several shots of each setup, because of all the variables involved; if you do this, you'll likely get just what you want on one of your frames.

Another variation, if you want to complicate the process further, is to change the lighting direction for each exposure. You could make a first exposure with the subject lit from camera left, then reposition the subject and flash unit to illuminate the subject from camera right, for example. Make sure you

carefully rehearse all the necessary repositionings in the light before trying them in the dark.

One interesting multiple-image effect involves combining a flash exposure, to freeze a moving subject in one position, with a continuous-light exposure, to blur the rest of the motion. Set up the flash unit and a weak (200-watt or thereabouts) continuous-light source (a household lightbulb in a 12-inch reflector will do) either right next to each other, or at different positions, as befits your envisioned final image. It's usually best to have both lights near the camera, so the subject is front-lit.

Determine the aperture based on the flash-to-subject distance. Then have the subject perform the desired action, and time it. Let's say it takes five seconds. Decide how much less exposure you want the whole action to receive than the frozen moment (usually two stops less is about right). Use a sensitive incident-light meter to determine where to position the lightbulb to produce this exposure. If the flash guide number calls for f/8, you'll want the lightbulb to call for f/4, at an exposure time equal to the duration of the motion (five seconds, in this example). So just move the lightbulb closer to or further from the subject until the meter reading calls for an exposure of five seconds at f/4, and you'll have the position for the bulb.

Now all you have to do is darken the room, open the shutter on B while telling the subject to begin the action, fire the flash at the desired point in the action (by using the open-flash button), and close the shutter when the action is complete. It's a good idea to shoot several frames, and bracket exposures, especially if your light meter won't read the dim light of a 200-watt bulb.

STROBE EFFECTS

Although electronic flash units are often called strobes, strobes are really flash units that flash repeatedly many times a second. You can approximate strobe effects with some electronic flash units, and you can use real strobes to produce real strobe effects.

When automatic flash units are used at close distances, or when variable-power units are used at low power settings, their recycling times are quite brief — one second or less. Some flash units have an autowinder setting, which lets them flash often enough to keep up with an autowinder — two or three times a second. With any of these units, you can put the camera on a tripod, set up and focus on your subject, darken the room, open the shutter on B, and fire the flash as rapidly as it will fire, thus freezing several points in the subject's motion sharply on your film.

The main drawback to this method is that these flash units don't put out a lot of light when set to recycle so rapidly. The reason they will recycle so quickly is that they use only a small portion of their power for each flash, so that only a little power must be replenished before they're ready to fire again. Real strobes, like the Wein Cronoscope and Balcar Monobloc (the former a small, inexpensive unit and the latter a more powerful and more expensive studio piece), are more versatile, flashing much more frequently (about 25 times per second), and emitting much brighter flashes.

These true strobes can be used for the same subjects as the simulated strobe effects described earlier, and others, because of their greater power and more frequent flashes. Pirouetting dancers, somersaulting gymnasts, and a hammer breaking a lightbulb (wear protective clothing, goggles, and gloves to prevent injury from the flying glass!) are just a few good subjects. At 25 exposures a second, you'll get 75 frozen images on one frame of film if the motion you're photographing takes three seconds to complete. Note: It's wise to consider the

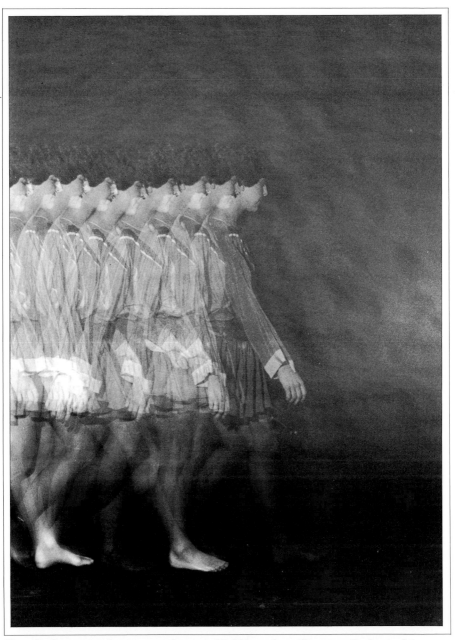

Here, the Cronoscope freezes many images of Debbie as she walks across the frame. A true strobe, the Cronoscope fires up to 25 times a second, permitting a variety of special effects limited mainly by the imagination. Note: Since each image of the subject is illuminated by only one flash from the strobe, but the background is illuminated by every flash, it's important to use a black backdrop that won't reflect light (or to shoot in a wide-open outdoor space at night); otherwise, the light will build up to produce a nonblack background, as is the case here (a plain black seamless paper background was used for this shot).

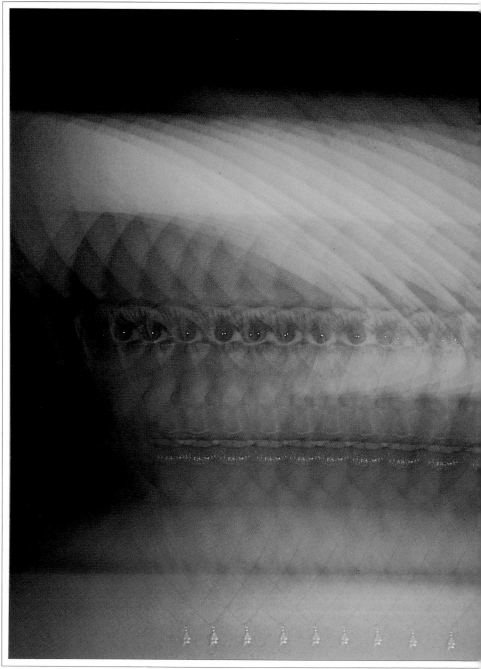

The subject doesn't have to move to produce strobe-effect images when using the Cronoscope. Here, Jim Zuckerman moved his camera sideways during the exposure, while the model remained still.

subject and motion before setting the strobe frequency — 75 images on one frame can make for a rather cluttered photograph. It might be better to set a slower firing rate, to space the images out more for clarity or artistic reasons.

GHOST IMAGES

When you're shooting pictures with electronic flash, the lens aperture controls the amount of light transmitted to the film, and the flash duration serves as the "shutter speed," controlling the duration of exposure. Thus, the shutter speed set on the camera doesn't matter, so long as it is within the camera's flash-sync capabilities. Most focal-plane shutter cameras permit a maximum flash sync shutter speed of 1/60 or 1/125 second — see your camera's operating manual. Since the flash duration is at least as short as the fastest shutter speed on most cameras (1/1000 second), the flash will sharply freeze many moving subjects on the film.

However, if the ambient light level is very high, and you use a very slow shutter speed, ghost images of the moving subject will appear on the film, because the slow shutter speed will be long enough to allow sufficient exposure by the ambient light. For example, if you want to make a flash shot of a cue ball hitting another pool ball, and the ambient light calls for an exposure of 1/2 second at f/8, while the flash guide number calls for an aperture of f/8, you can produce two different images. If you shoot with the camera shutter set for 1/60 second, the flash will sharply freeze the two balls at the spots they occupy during the 1/1000 second the flash fires, and their images during the rest of the 1/60-second exposure will be five stops underexposed. If you shoot at a shutter speed of 1/2 second, though, the flash will still freeze the balls at the spots they occupy during the flash's 1/1000-second duration; now, however, the ambient

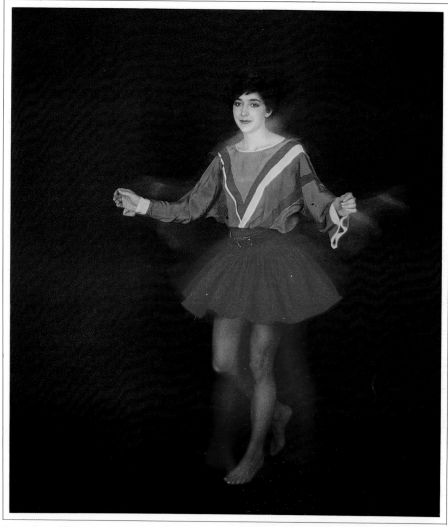

To produce this image, I took a reading of the two umbrella-mounted flash units with a flash meter (it said f/8), then took an incident-light reading of the ambient light to determine what exposure time was required at f/8 (it said four seconds). As Debbie spun during the four-second exposure, producing the blurred ghost images, I fired the flash units once when she was facing the camera to produce the sharp image.

light exposure matches the flash exposure, and blurred images of the balls will appear where they moved across the frame during the 1/2-second exposure. By adjusting the shutter speed during flash exposures, you can control the effect of the ambient light on the image.

Longer shutter speeds will increase the effect of the ambient light; shorter shutter speeds will decrease it.

Another way to produce ghost images with flash is similar to the way you'd produce them in ambient light: make one exposure with your subject in the

scene, and a second exposure on the same frame with the subject removed (each with the lens closed down one stop from the normal exposure for the scene). For example, if your subject is a person sitting in a chair, and the flash guide number calls for an aperture of f/8, set the lens at f/11 and make an exposure; then have the person leave the scene, and make a second exposure on the same frame. If your camera won't make in-register multiple exposures, set up the scene in a room that can be darkened completely, focus the lens and set the appropriate aperture, then darken the room, open the shutter on T or B, fire the flash, have the subject leave the scene, fire the flash again, and then close the shutter.

PAINTING WITH LIGHT

Painting with light is a technique that enables you to illuminate a large subject or area evenly with just one flash unit. Basically, the technique consists of opening the camera shutter on T or B, carrying the flash unit around and firing it at various positions so that the whole subject or area is evenly illuminated, and then closing the shutter.

If your camera has a T setting, this will keep the shutter open until you press the shutter release a second time. If your camera doesn't have a T setting, use B and a locking cable release to hold the shutter open until you're through firing the flash. Use the open-flash button to fire the flash unit.

Naturally, you can use this technique only in dark places; otherwise the film will be overexposed by the ambient light during the long period the shutter is open. You can minimize the possibility of overexposure by using slow film.

Subjects in the scene that move during the time the shutter is open will appear as ghost images or not at all in the photograph, depending on how long they stay in one spot before or after moving.

You can put yourself in several places in the picture by firing the flash at yourself at several positions in the scene.

Attach the camera to a tripod and compose the scene as you want it. To decide where to fire the flash unit, think of where you'd put individual light sources to produce the effect you want; fire the flash at each of these locations. Determine the proper aperture by using the flash unit's guide number and the average distance the flash will be from the subject (or the walls of the room, if a room is the subject). It's wise to bracket exposures by shooting one frame at the calculated aperture, another with the lens opened one stop, and a third with the lens closed down a stop. If you're shooting outdoors at night, begin the exposure series with the lens opened two stops from the calculated exposure (to compensate for the lack of reflecting surfaces) and bracket from there.

Before turning off the room lights, walk through the scene and rehearse aiming and firing the flash at the appropriate spots. During this rehearsal, check to see that you won't trip over anything in the dark (if your subject is a room, a weak night light in an adjoining room out of camera range will provide enough light so that you can see what you're doing). Make sure you don't walk between the flash unit and the lens while firing the flash, and don't point the flash at the lens. Don't aim the flash into windows, mirrors, or glass picture frames that will reflect glare into the lens.

Once you're satisfied with your walk-through, you're ready to make the shot. Darken the room, open the shutter, walk through the scene and fire the flash at the determined spots, then close the shutter, and you've got your shot. Be sure to wait until the flash unit fully recycles between firings — wait for the ready light to come on, plus an additional three or four more seconds, to be sure that each flash will be at full power.

13

Projected Image Effects

THERE ARE TWO BASIC WAYS TO PRODUCE special effects with projected images: project an image onto a subject, for an abstract effect; or project an image on a screen behind the subject, to put the subject into a new environment.

FRONT PROJECTION

You can use a slide projector to project the image from one of your slides onto anything you can put in front of the projector. For best results, your subject should be something light in tone, so that the projected image will show up well on it. Human faces and figures make fine subjects, but you can project images onto rumpled Mylar (either straight on or at an angle), a volleyball, or anything else. The most difficult part of front-projection special effects is selecting a subject on which to project an image, and an image to project onto the subject.

Since slide projectors employ tungsten bulbs, you should photograph your projected images using tungsten-balanced color film if accurate color rendition is important. For many special-effect images, correct colors aren't important, though, so you can try using daylight-balanced films, and even color infrared film, for unusual effects.

Use a reflected-light meter (the meter built into your camera will do nicely) to determine exposure, and then bracket two stops each side of the indicated exposure — a lighter or darker image might be more effective than a "normal" one. Projected images on most subjects aren't very bright, so exposure times will be longish (1/2 second and longer, generally); attach the camera to a tripod for sharpest results.

Focus the projected image on the main subject with the slide projector's focusing mechanism (unless you want the projected image out of focus for a specific effect), then focus the camera lens on the subject's surface, and stop down to at least f/8 to provide sufficient depth of field.

You'll normally get best results by positioning the subject in front of a black background, so that all you'll record is the projected image on the subject. However, sometimes you can produce effective images by placing the subject in front of a white background, and letting the projected image spill over onto the background. Naturally, you'll want the room in which you make the shot to be as dark as possible, so that the projected image will stand out strongly.

For more variety, you can project textures onto your subject. Commercially available 35mm texture screens, or homemade ones created by shooting slides of textured subjects, can be placed in the slide projector and projected like slides.

You'll always have to shoot your subject at a slight angle, because if you put the camera right in front of the subject, it will block some of the light from the projector. This is another special effect, but rarely a satisfactory one. For most purposes, you'll want to keep the camera (and yourself) out of the projector-subject line of sight.

REAR PROJECTION

If you want to photograph your subject in a new environment, you can do it by projecting a slide image of that environment onto a projection screen behind the subject. Since the image will be projected onto the subject as well as the screen if the projector is in front of the

screen, the technique of rear projection is the best way to do this. Many motion-picture special effects are created this way, albeit with much more sophisticated gear than is available to most of us.

To produce rear projections, you'll need a translucent rear-projection screen. Special commercially produced rear-projection screens are available at photo dealers, but for almost all of your special-effect work, less costly matte acetate (available at art-supply stores) will suffice. You can build a simple wooden frame of the desired size, and attach the acetate with staples or brads.

Set up your slide projector behind the screen, and focus the image on the screen in the usual manner. If it's important that the background image be laterally correct, you'll have to put the slide in the projector backward; otherwise the projected image will appear backward when viewed from the front. Darken the room to obtain a sufficiently bright image on the screen.

Position your subject in front of the screen, and carefully light only the subject — if any light falls on the screen, it will wash out the projected image. Read the image on the screen with your light meter, then adjust the lighting on the subject until you get the same reading, in order to balance the exposures. Do this if a realistic effect is desired — if realism isn't important, you can light the subject more brightly than the screen image's intensity, or vice versa.

Exposure times will be rather long, so you should attach the camera to a tripod to prevent blur due to camera movement. Stop the lens down as far as possible to maximize depth of field (you'll generally want both subject and projected background to appear sharp in your photograph), bearing in mind that human subjects won't be able to hold perfectly still during the several-second exposures made necessary by the use of very small apertures.

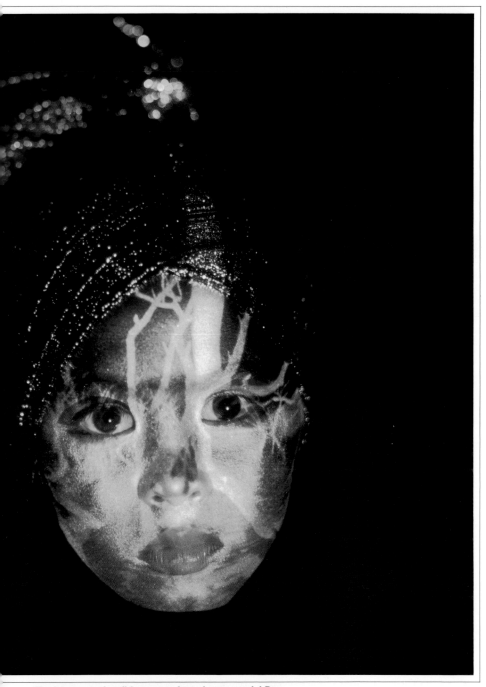

The image on the slide was projected onto model Bee Ontrakarn's face instead of onto a projection screen, and then rephotographed. Photo by Jim Zuckerman.

163

Rear projection lets you put anything you have on film behind your subject. Here, photographer Jim Zuckerman projected the image of the tiger onto the back of a rear-projection screen, set up his subjects on Mylar in front of the screen, lit the subjects so that no light fell on the screen, then photographed the setup.

As with front projections, use tungsten-balanced film if correct color rendition is important. It usually is with rear projections. Possible subjects for unusual rear projections are limited only by your imagination. You can use the technique to place someone in an exotic, faraway place, to put a teddy bear into a crowd of people, to launch a toy airplane into a lovely sunset or even amid city sky-

To produce this photo, Jim Zuckerman projected his original slide of the girl in the cave onto the back of the rear-projection screen, put a container of water in front of the screen, and photographed the resulting reflection and projected image.

scrapers — anything you'd like. All you need is an idea, a subject, and a suitable background slide.

Without the extensive and expensive equipment of professional movie special-effects studios, your rear-projected images will be somewhat diffused and unsharp, but they can still be very effective, particularly if you take care when setting them up.

Using two projectors (get together with a friend), you can project two images onto a sheet of white poster board (a projection screen has a texture that would show in the photo), then rephotograph the resulting double image. Jim Zuckerman, who carefully selected images that would complement the shots of model Bee Ontrakarn to produce these photographs, suggests positioning the projectors near the poster board to give small, sharp images, and close to each other to minimize keystoning, since each projector will be aimed at a slight angle to the poster

board. The remaining keystoning can be eliminated by cropping in on the projected images slightly; this, in turn, requires the use of a telephoto lens on the camera, because the camera will have to be behind the projectors so there will be room to get your eye to the viewfinder. Keep the camera's film plane as parallel to the poster board as possible to avoid camera-induced keystoning. As with all photography of projected images, you should darken the room, and use film balanced for the projector light source (generally, tungsten film).

Glossary

Ambient light. The light that exists at the scene, as opposed to light provided by the photographer. Also called existing light.

Anamorphic lens. A lens that compresses or stretches the image laterally, vertically, or diagonally. Originally produced for professional movie work, an anamorphic lens on the camera compresses a wide scene so it fits onto the film frame; another anamorphic lens on the projector then expands the image so that it fills the screen.

Aperture. The opening in the lens that permits light to go through to the film. The size of the aperture is controlled by the lens aperture ring, which is marked in f-numbers.

ASA speed. A numerical rating of a film's sensitivity to light, based upon standards established by the American National Standards Institute (ANSI, formerly known as the American Standards Association, or ASA). A higher ASA number indicates greater sensitivity to light; a film with an ASA speed of 400 requires half as much light as one with an ASA speed of 200. ASA speeds are now being replaced by ISO (International Standards Organization) speeds, which consist of the film's ASA number followed by its DIN (European rating system) rating: ASA 400 = DIN 27 = ISO 400/27°.

B setting. Setting on a camera shutter that keeps the shutter open as long as the shutter-release button is depressed. Used to make long exposures.

Bracketing. Shooting one frame at the exposure you think is correct, then shooting additional frames, giving more and less exposure, to ensure that you'll get one properly exposed image.

Cable release. A flexible length of cable that screws into the camera's shutter release mechanism and permits tripping the shutter without applying direct pressure, thus minimizing camera movement due to this pressure. A locking cable release contains a lock mechanism that can be used to hold the shutter open for long exposures.

CC filters. Color compensating filters come in the six primary colors (red, blue, green, magenta, cyan, and yellow) and various densities (.05, .10, .20, .30, .40, and .50), and are used to fine-tune color balance when shooting or printing color photographs. They can also be used to enhance colors existing in a scene.

Close-up lens. A simple plus-diopter lens resembling a clear filter, which enables a camera lens to be focused closer than its normal minimum focusing distance.

Color-spot filter. A colored filter with a clear spot in the center, used to produce images in which the central subject is surrounded by color.

Daylight film. A color slide film designed to produce correct color rendition when exposed by daylight.

Depth of field. The area in front of and beyond a point focused upon in which the subjects will appear acceptably sharp in a photograph. Depth of field is greatest at small apertures.

Dichroic. Two-colored.

Diffraction grating. A thin sheet of glass or other material containing many closely spaced parallel lines that break up light into its component colors.

Diffusion. A soft effect that blends light areas into dark ones, rather than producing the usual sharp edges between light and dark areas in a photograph; produced by diffusion filters and soft-focus lenses.

Diopter. A measure of the strength of a close-up lens. The reciprocal of a close-up lens's diopter rating equals the distance (in meters) at which the camera lens will be focused using the close-up lens.

E.I. Exposure index. Any speed (using ASA numbers) at which a film is rated other than its ASA speed. For example, Kodak Tri-X has an ASA rating of 400, but many photographers rate it at E.I. 250 or 320 to produce the results they desire.

Filter factor. A number indicating how much the exposure must be increased to compensate for light absorbed by a filter. A filter factor of 2× means the exposure must be doubled when using the filter.

Fisheye lens. A lens that takes in a 180-degree (or greater) angle of view. The front element bulges out like a fish's eye. Two types are available: circular fisheyes, which produce circular images covering 180 degrees in all directions; and full-frame fisheyes, which produce rectangular images covering 180 degrees diagonally.

Flare. Bright spots and shapes and an overall loss of contrast in the image caused by extraneous light striking the front element of the lens during exposure. Flare can be prevented by using a lens hood and aiming the lens so that no extraneous light strikes its front element.

Flash duration. How long the burst of light from a flash unit lasts. Most electronic flash units have durations of 1/1000 second or shorter, giving them great action-stopping power.

Focal length. The distance between the optical center of the lens and the film plane when the lens is focused at infinity. The longer the focal length of the lens, the greater the magnification and the smaller the angle of view.

Fog filter. A filter that makes a scene look Foggy. Fog filters scatter the light, lowering contrast, muting colors, producing halos around lights, and giving an overall softness to the image.

Front projection. Standard setup for projecting slides, with the slide projector located in front of the screen.

Ghost image. A blurred or semitransparent image produced when a subject is in the scene being photographed for only a portion of the exposure time.

Graduated filter. A filter that blends gradually from cne effect to another, such as from a colored area to a clear one, a neutral density area to a clear one, or a diffused area to a clear one.

Gray card. A small gray-colored card of medium reflectance from which reflected-light meter readings can be made to eliminate the adverse effects of unusually light or dark subjects on the reading. The Kodak Neutral Test Card (18% reflectance) is an inexpensive and versatile gray card.

High key. An image consisting primarily of light tones, with only a few dark accent tones present.

Incident-light meter. An exposure meter that measures the light incident (falling) upon the subject.

Infrared radiation. Wavelengths just beyond the longest red wavelengths of the visible spectrum. Normal films are not sensitive to infrared radiation, but special infrared-sensitive films are available for scientific and special-effects photography.

Laser filter. A holographically (laser) produced diffraction grating, which contains families of parallel lines and produces patterns of spectral colors, rather than just the straight spectral lines of standard diffraction gratings.

Low key. An image consisting mainly of dark tones, accented by just a few light tones.

Matte box. A bellowslike lens hood containing slots for cards that produce special effects such as putting one subject in a scene in several spots, putting one subject in the center of a second subject, shaped vignettes, and more.

Mirror lens. A long–focal-length lens that employs mirrors to "fold" the light back and forth, thereby producing a long focal length in a relatively compact package. Because of their construction, mirror lenses turn out-of-focus highlights into doughnut shapes.

Monochromatic. One-color.

Multiple-image filter. A filter composed of several facets, which produces several images of a subject at a time.

Neutral density filter. A filter that reduces the amount of light transmitted without otherwise changing it.

Open-flash button. A button on a flash unit that fires the unit when pressed.

Orthochromatic film. Film sensitive to blue and green light, but not red light. Red objects on orthochromatic film appear very dark in prints, since the film is not sensitive to the light they reflect.

Panchromatic film. Film sensitive to all three primary colors of light (blue, green, and red). Most common black-and-white films are panchromatic.

Panning. Tracking a moving subject with the camera, to produce an image with a relatively sharp subject but a blurred background to emphasize motion.

PC socket. Receptacle on the camera to which a flash unit is connected. The flash is fired when the shutter is tripped.

Physiogram. A pattern produced by a point-light source (such as a penlight) swinging on a string.

Polarized light. Light vibrating in one plane. Normal (nonpolarized) light vibrates in all planes perpendicular to its direction of travel.

Polarizing filter. A filter that polarizes light, thus reducing or eliminating reflections from nonmetallic surfaces, darkening the sky, and producing saturated colors.

Rear projection. Alternative setup for projecting slides in which the image of the slide is projected onto the rear of a translucent screen, and viewed or photographed from the front of the screen.

Reciprocity failure. Failure of the reciprocity law to hold true at very long or very short exposure times; a loss of film speed at very long or very short exposure times.

Reciprocity law. E = It; exposure equals the product of the light intensity and the time of exposure. True for exposure times between 1/15 and 1/1000 second with most camera films — an exposure of 1/250 second at f/8 = an exposure of 1/125 second at f/11 = an exposure of 1/500 second at f/5.6 At very long or short exposure times, the lens might have to be opened more than dictated by the reciprocity law, to compensate for reciprocity failure.

Reflected-light meter. An exposure meter that measures the light reflected from the subject or scene.

Sandwich. Two images placed in contact with one another, such as two slides, or a slide and a texture screen, to produce a new image.

Selective focus. Focusing on an important portion of a subject while using a large lens aperture to minimize depth of field, and to emphasize the sharp portion of the subject.

Slide copier. A device that holds a color slide at a fixed position relative to the camera and produces sufficient magnification to allow the slide to be rephotographed. Slide copiers range from simple, inexpensive tubes that attach to the camera or lens to expensive multifunction copy machines.

Soft-focus. An overall soft effect in an image, produced by the gradual merging of light and dark areas, while retaining some subject detail (as opposed to out-of-focus, in which the entire image is unsharp).

Split-color filter. A filter that is half colored and half clear, or half one color and half another.

Split-field lens. A lens attachment that is half close-up lens and half clear glass.

Star filter. A filter containing a grid pattern that turns point-light sources into stars in a photograph.

Strobe. An electronic flash unit that fires many times a second. Many photographers incorrectly refer to all electronic flash units as strobes.

T setting. A setting on some camera shutters that keeps the shutter open until the shutter release is pressed a second time.

Texture screen. A piece of film or other transparent material containing a texture pattern, which can be sandwiched with an image to add texture.

Tungsten film. Color slide film that is designed to produce correct color rendition when exposed in tungsten lighting.

Vignetter. A filter containing a clear central area surrounded by diffusing material, which produces an image in which the subject fades away at the edges.

Zoom lens. A lens whose focal length can be changed by turning a ring or operating a push-pull control. Unique special effects can be produced by "zooming" the lens during a long exposure.

Index

Numbers in italics indicate data contained in photograph captions.